CRAFTS
TODAY AS YESTERDAY

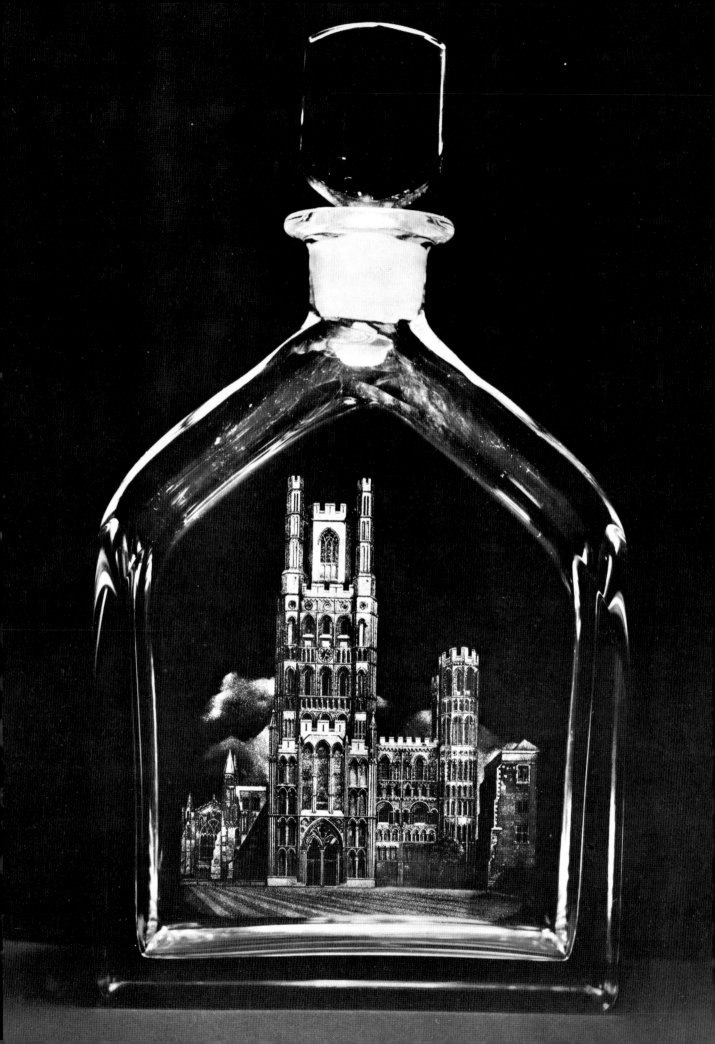

CRAFTS
TODAY AS YESTERDAY
IN COLOUR

Photography and text by

DAVID GIBBON

Produced by

TED SMART

COLOUR LIBRARY INTERNATIONAL LTD.

To my wife Maureen

First published in Great Britain in 1976
by Colour Library International Ltd.

Photography David Gibbon
Text David Gibbon

Designed and produced by Ted Smart

Separations and Printing by
Creaciones Especializadas de Artes Graficas, S.A.,
Las Planas, S/N, San Juan Despi, Barcelona, Spain.
D. L. B.-7.686/76
Display and text filmsetting by
Focus Photoset Ltd.,
134 Clerkenwell Road, London EC1R 5DL.

ISBN 0 904681 06 8

Enquiries should be sent to:

Colour Library International Limited
80-82 Coombe Road,
New Malden, Surrey KT3 4QZ. Tel. (01) 942 7781

COLOUR LIBRARY INTERNATIONAL LIMITED

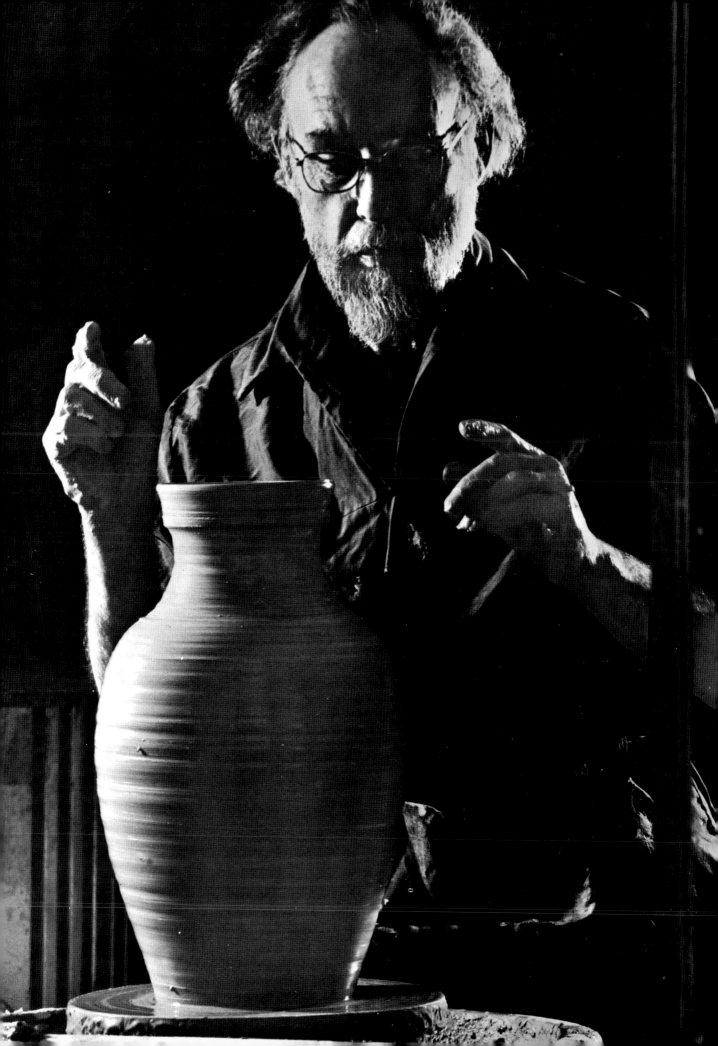

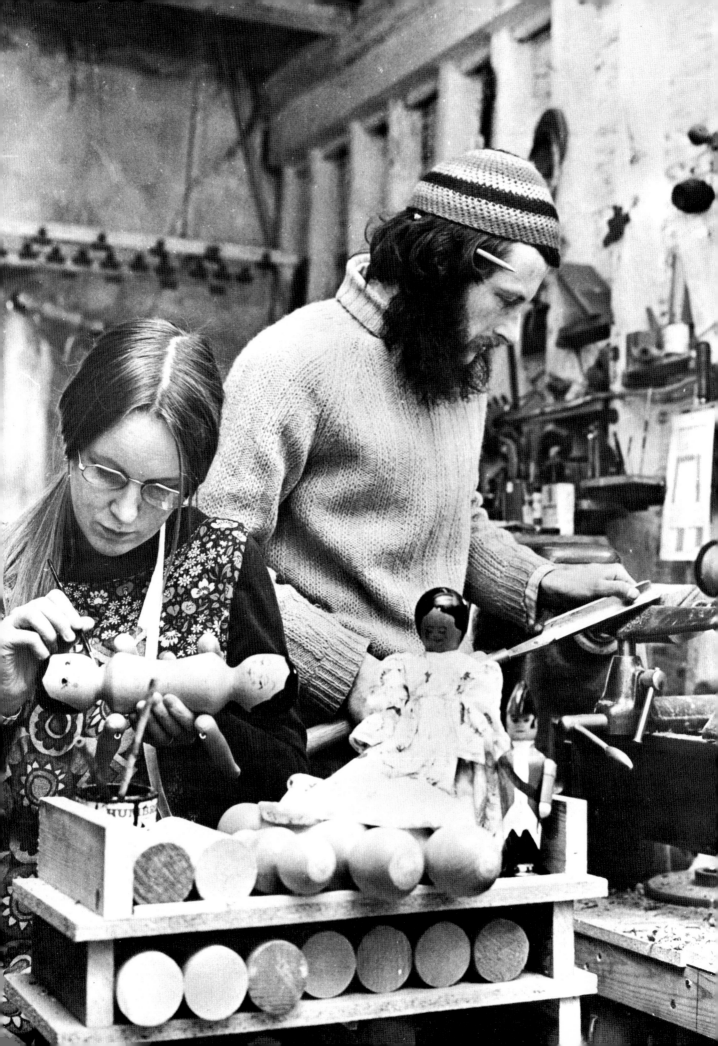

CONTENTS

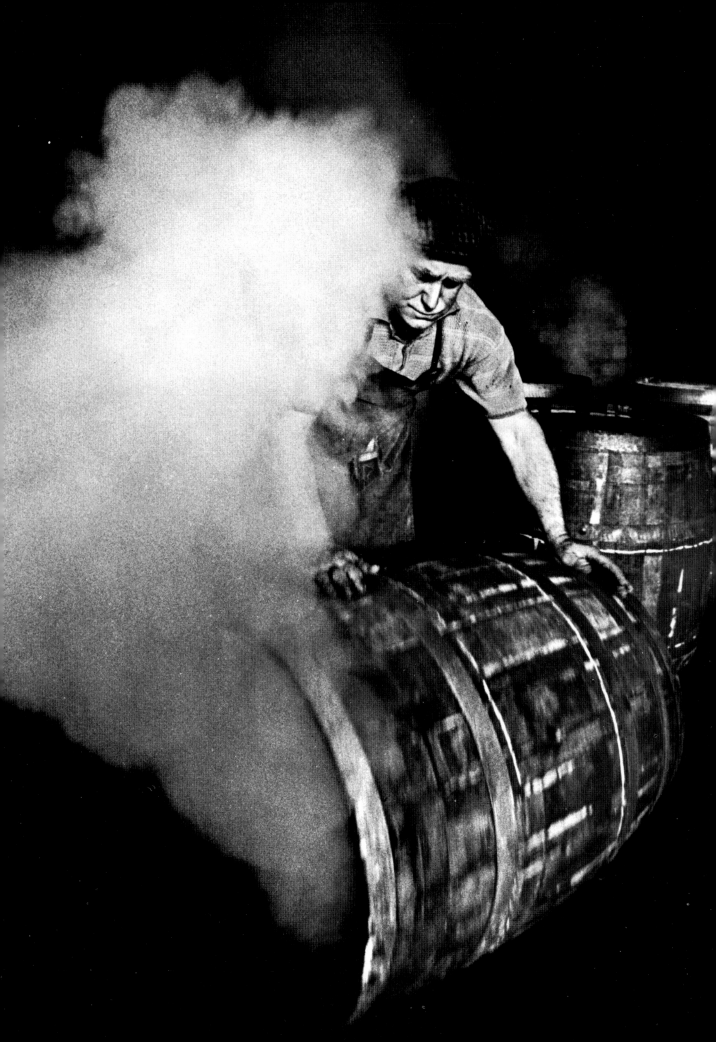

INTRODUCTION

The greatest cause for celebration in compiling this book has been just how much, what wealth of craftsmanship, and how many craftsmen and women, had to be left out. When the idea was first concieved I must admit that I viewed it with some mis-givings, for I imagined that the greatest difficulty would be in finding enough people working in quite different fields to make the book interesting. I also thought that, at best, I would find a number of elderly craftsmen carrying on a tradition started generations ago, and not likely to be continued once they retired. I was quite delighted to find that I could not have been more wrong in my assumptions. Craftsmanship is alive and well, and thriving in almost every part of the country. True, some crafts are dying out, but far fewer than might be imagined. The heartening fact is that new crafts are gradually emerging to take their place, and that there is no lack of younger people wanting to play their part in continuing the long tradition of craftsmanship of which we, in Britain, can be so proud. Whether this point could have been made a few years ago is debatable. It seems we are slowly emerging from a tunnel in which plastics and mass production reigned supreme, a throw-away society in which built-in obsolescence was the order of the day. To a very large extent we are still very much in the tunnel, but at least people are now beginning to question the values of the society in which they find themselves. Advertisers are by no means slow to spot trends and changes, indeed their very livelihood depends on their ability to foresee them. It can be no matter of chance, therefore, that we now find ourselves surrounded by exhortations as to the 'home made' or 'country fresh' flavour or atmosphere of one product or the other. However spurious any or all of these claims may or may not be, they do reflect a desire on the part of a growing number of people for something that at least sounds, and looks, genuine – and possibly may

even be so. The human race appears all too ready and eager, in fact it seems to have a compulsion, to want to put labels on everyone and everything. We are rather surprised, and slightly disconcerted, to find that, for instance, the plumber who comes to mend a dripping tap has had several volumes of poetry published, or that the sophisticated and romantic actor we see on our screens enjoys nothing so much as messing about in his vegetable garden. So odd do we find such behaviour that it becomes worthy of inclusion in a newspaper or magazine. And yet it is not in the least odd; all of us have many and varied interests but we tend to ignore them, in ourselves and other people, and concentrate only on what we can most easily understand.

Because we have this tendency to put people in slots we too often apply it, all too rigidly, to ourselves and we become the most serious casualty of such thinking. We tend to take a serious interest in only those things that fit in with the particular slot in society in which we find ourselves. Anything else labels us as odd or eccentric. Fortunately there has always been a proportion of people who have been willing to be thought of as such, who have been prepared, to use an overworked expression, to 'do their own thing'. I well remember Joe Bonham, who is a fishing rod maker of renown and is the subject of one of the sections in this book, telling me about a customer of his. Apparently he used to go down to Joe's workshop and ask to be ignored, and for Joe to simply carry on with his work as though he was not there. The customer was an eminent brain surgeon, a teaching consultant, who gradually 'confessed' to Joe that what he really wanted, above all else, was to be a maker of fishing rods. This was no idle interest, it continued for some years and, as Joe Bonham realised how serious he was he started to teach him his craft. The surgeon was an apt pupil and progressed to the stage where he decided that he would give up his career and take up this new one. All was arranged, but the surgeon died before it could come about. Had he lived, and fulfilled his ambition, he would no doubt have been considered eccentric to say the least. There are many instances such as this of people wanting to get out of their slot and change their way of life completely. There must be many, many more who simply think about

it but never even talk of it, let alone ever attempt to do anything towards it. The relevance of all this, and perhaps the surprise, is that so many of us, in so many different occupations, have such a strong desire, when we think about such things, to do something we consider creative, to become a writer, a painter, or perhaps a fishing rod maker. It could be that the answer lies in 'job satisfaction' for there are not too many true craftsmen, in the broadest sense, who would willingly exchange what they do, or their way of life, for anything else.

However artificial and arbitrary classifications and categories may be, the fact remains that they do exist. In admitting this we have, therefore, to ask some questions about the particular group of people who are the subject of this book. What then is a craft, and where do we draw the distinction between workmen, craftsmen, and artists? My dictionary defines craft as 'a manual art, a trade needing a high manual skill, art applied to useful purposes'. It seems that we are already in difficulties. When is workmanship craftsmanship? When does craftsmanship become artistry? If the engraver produces a design on a flat piece of glass that serves no useful purpose, but that can be framed and hung on a wall, then this is, presumably, art. If the same design is now engraved on a decanter, which serves a useful purpose, is it now craftsmanship rather than art? Are Stuart King's superb miniature chairs to be considered as art rather than craft, because they serve no useful purpose as chairs? We have already been tripped up by our desire to classify things and people. Every artist employs workmanship and craftsmanship, and every workman and craftsman can be capable of artistry. We have to widen our categories. I think we can only loosely define craftsmen as people usually doing exactly what they want in producing an article that serves a purpose, and achieving, and practising, the highest possible levels of skill and expertise in so doing. Whether it reaches the level of what we call 'art' is up to each individual to decide. Interestingly enough, there have been several cases of highly functional, craftsman made products, that have been prized simply as things to be looked at, handled, and admired, and have never been even considered for use for the purpose for which they were made. A case in point concerns the cameras made by the

Gandolfi's in Peckham, South London. There is a vogue at the moment for antique camera collecting and, whilst this can take many different forms, from a general collection including old box cameras and such like, the old wood and brass stand cameras are very much sought after. The Gandolfi brothers are still making such cameras, and hopefully they will continue to do so for at least a few more years. Nevertheless there are people actually including these highly functional products in their collections which have never been used to expose a sheet of film, so highly regarded is the craftsmanship that goes into their construction. I have even heard of a wooden putter being bought for the same reasons, and it will almost certainly never see a putting green! Much as this may be a tribute to, and regard for, the workmanship of the craftsmen concerned, I am quite sure they themselves would think it rather silly. Above all the products of the craftsmen are designed to work, to do the job for which they were intended, rather than to be regarded as works of art.

There was a time, of course, when all things were hand made. They were then, presumably, either considered to be well made or poorly made and the fact that they were hand crafted didn't enter into it. We have now reached the stage where the fact that something is hand made is cause for comment, and we must be careful that we re-learn to distinguish, surely on the basis of the article fulfilling its function, between the good and the not so good. It would be quite wrong to encourage craftsmanship for the wrong reasons and accept a poorly made product only because it is hand made. That way lies a cheapening of craftsmanship, and a denial of its very name.

Many of the people featured in this book work entirely alone or, perhaps, with the assistance of their wives or husbands. This highlights one of the problems common to all craftsmen and to the continuance of a very high standard of workmanship; the problem of an ever increasing demand. If an article is outstandingly well made, very beautiful, or fulfils its function extremely well, then it is not surprising if, even without the benefit of advertising, a considerable demand for it is created. Up to this point the very objectives of the craftsman have been achieved; his work is good, people buy from him

and his work is seen by more people who, in turn, want what he can produce and he, naturally, wants to meet this demand if he possibly can. A time can come, however, when this very demand can become an embarrassment; when, even working all the hours he possibly can, he cannot cope. When this crossroad is reached he can do one of several things. He can, if he wishes, examine his method of working and perhaps lower his standards to try to increase his output. Most craftsmen would find this course unacceptable and, in any case, if the demand for his work is really considerable it would alleviate the problem to only a very small extent. In many cases the craftsman can, and does, simply carry on as he always has. He has an order book and, when orders come in he simply adds them to those already in it and works his way through them. This, whilst ensuring that he does not have to compromise his craftsmanship, does mean that he has to quote increasingly lengthy delivery dates. Some delivery times, as in the case of several of the craftsmen in this book, can run into years rather than weeks or months. A product has to be of a quite outstanding nature for potential customers to put up with delays of this kind and it may be that many orders will be lost because of it. This is something that can be ignored by the craftsman when things are going well, but at other times, when money is perhaps not so readily available, or there is not quite so much interest for any other reason, then the craftsman will wish he had been able to meet orders he now misses. There is another, and obvious, way that increasing demand can be met and that is to employ other people to share the work load. It would be wrong to suppose that, just because a number of people are employed, or have got together, to create a product, craftsmanship no longer exists. There are many examples of both small groups of people, and even large companies, where superb craftsmanship continues to flourish. Obvious examples of craftsmanship on a large scale that come to mind are those to be seen at Alfred Dunhill and Charatan Pipes, both in London. In both cases quite a number of people are employed and many different types of machines are used. Not everyone employed can be considered a craftsman in his or her own right, though there are a number of highly skilled craftsmen in each company. Nevertheless, the overlying

emphasis is on craftsmanship, and the final product, for which both names are justly famous, demonstrates this to a very high degree indeed. At the same time such a situation usually takes the responsibility for the whole product out of the hands of one man, and in many cases it is this very aspect that the customer looks for in the craftsman's work. To take another example, at the other end of the scale from the larger companies, it is very hard to see how a glass engraver like Patrick Heriz-Smith could shorten his waiting list other than by employing, or going into partnership with, another glass engraver. If this were to happen the customer would not be getting what was commissioned; a glass engraving by Patrick Heriz-Smith. No easy answer exists to a problem such as this. Each craftsman must obviously decide for himself which course to follow. He will probably be thankful enough that he has such a problem of too much demand for his work, rather than the reverse!

Crafts are entered into for a variety of reasons. Certainly in the case of rural crafts in the old days is was in most instances, a matter of following the family tradition. If your father was a blacksmith, or a farrier, then the odds were that you would follow in his footsteps in much the same way as sons followed fathers down the mines, or into the mills, in industrial areas. Things have changed now and there is not the same compulsion, or need, to follow in anyone's footsteps. We can, to a large extent, choose the job or profession we wish. I should think it unlikely that many people decide to take up a craft, and to make it their life's work simply for the money they can get out of it. A very few do make large sums of money, but most of them do not. They make a living, and what they do not gain in financial rewards is, they feel, compensated by their freedom to do what they want without any, or with very little, interference from outside. This wish to achieve some measure of individual freedom is certainly one of the factors that many craftsmen take into consideration, particularly those who work on their own. There is also the strong desire to do something in their own way, something they feel they will be good at and eventually become masters of.

The problem a craftsman faces when it comes to a question of

deciding on a price for his product, or a fee for his services, can be a very difficult one. If he or she were to charge the customer, on a basis of time alone, at the average hourly rate paid throughout the country then, in many cases, it would put the price up to an unacceptably high level. The problem is that so few people realise, looking at a hand made article, just how much time went into its making, and this is disregarding the many years that may have been spent in perfecting skills. If, on the other hand, too low a price is charged the product tends to be regarded as too cheap, and therefore not worth having, and the craftsman finds he cannot earn a living.

There are, in this country, organizations whose purpose is to encourage and assist, in many different ways, the growth and prosperity of craftsmen and craftsmanship. The Crafts Advisory Committee maintains a selective list of craftsmen whose work is illustrated in a library of colour slides. Many of these are available, on loan, for lectures or other purposes which will promote interest in various crafts and help to make sure that the craftsmen's work is made known, and sold, to as wide a section of the public as possible. CoSIRA –the Council for Small Industries in Rural Areas–is another such organization. To quote from one of their publications…."CoSIRA is an advisory and credit service, sponsored by the government, to assist small firms in rural areas of England and Wales. Its aim is to help small firms to become more prosperous and so provide more employment in the countryside. If the firm is a manufacturing or servicing industry or business, employing not more than twenty skilled persons, and is situated in a rural area or in a country town with a population of ten thousand or less, then it is eligible". Both these organizations publish a comprehensive index of craftsmen and, in the case of CoSIRA, craft shops.

The importance of crafts shops should not be underestimated. They are, quite often, the only contact the craftsman has with the public and the placing of products in carefully selected outlets can do much to assist him in placing his work before the public, leaving him to concentrate on what he does best. Most good craft shops are quite knowledgeable about craftsmen in the area and will usually be only

too pleased to put potential customers in touch with craftsmen whose specialised services they require.

It seems that we are rather apt, in this country, to denigrate our achievements, and particularly to question our own capacity for hard work. Watching craftsmen at work in various parts of the country, and in widely differing fields, I can only come to the conclusion that we are grossly wrong in this assumption. What seems, in my humble opinion, to be at the root of the problem is a peculiarity in the British character. If we are left alone to do a job that interests us, that we consider worthwhile, and resulting from which we can perceive our part in an end product, then we seem to have an infinite capacity for hard work and good workmanship. The enormous growth of 'do-it-yourself' is an excellent indication of this, as is the popularity of gardening, requiring a considerable amount of hard work and patience. If, on the other hand, we are regimented, formed into large groups, and expected to do a job we neither fully understand nor see the purpose of, then we are inclined to rebel, to lose what little interest we had, and to look for ways of avoiding it. Perhaps the mass-production methods of other countries are just not suited to our independent nature.

Another aspect of the British character is that we resist, very strongly, anything we consider to be intrusion or exploitation. If, however, you show that you intend neither to intrude nor to exploit, but that you are genuinely interested in what is being done and in the person doing it, nothing is too much trouble and the friendliness that is shown, and the help given, is quite remarkable. When I first set out to interview and photograph the craftsmen in this book, I did so with some trepidation. My fears were totally without foundation. Whether I went to a larger company or to one person working alone I met with the same response; eagerness to help, complete co-operation, and a genuine friendliness towards me, and interest in what I was trying to to. Phrases of thanks and appreciation have become very overworked, and it is therefore difficult for me to convey my gratitude to all the many people I have met. I trust, however, that they, at least, will know how sincerely I thank them for all that they have done and that the pictures will somehow help to convey my gratitude.

Clockmaker Extraordinary.

If Mr Michael Potter had succeeded in his original ambition he would, by now, be deeply involved in the world of motor engineering and horology would have lost an exceedingly fine craftsman. From a very early age he was fascinated by things mechanical and took great delight in finding out how they worked. At this stage it was his intention to study motor mechanics and engineering with a view to ultimately setting himself up in business. The war intervened, however, and at its cessation he decided that his first love, clocks, would become his life's work. Clockmaking and repairing are crafts not easily learnt and Michael Potter accordingly served an apprenticeship with Charles Frodsham and Company, the holders of the Royal Warrant.

The responsibilities that go with this particular Royal Warrant involved then, as they do now, the maintenance of all the clocks in Buckingham Palace. That Michael Potter displayed an extraordinarily high skill in his chosen profession must have quickly become apparent for, some sixteen years ago he was awarded the ultimate accolade of the clockmaker by being given the responsibility for carrying out his company's obligations in looking after the three hundred clocks in Buckingham Palace in addition to others in various parts of London. When we talked about the problems involved in such a task he had no hesitation in telling me that what gives him the greatest single difficulty is the day, each October, when British Summer Time ends and, in one day, all the three hundred clocks, some of them very old and delicate, some virtually priceless, have to be put back by the one hour necessary!

The shop and workshop in Worcester Park, where Michael Potter has lived for the past twenty seven years are an absolute delight to anyone interested in beautiful clocks and superb craftsmanship. He never seems to tire of his occupation and still spends hours at his small lathe, fashioning small parts that will go into the mechanism of another clock he is constructing.

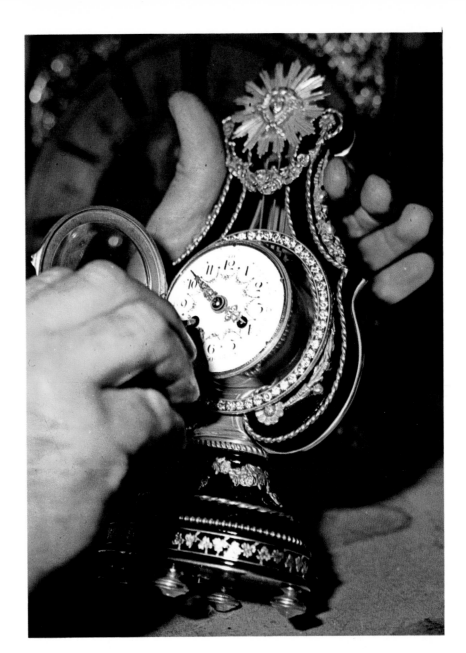

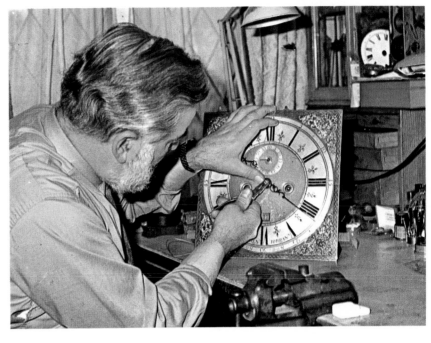

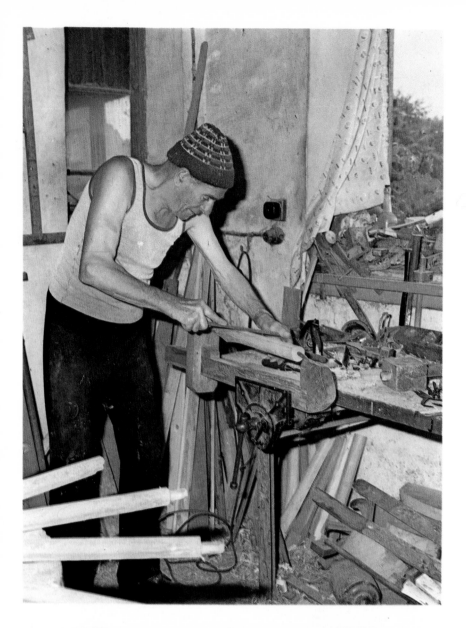

The Wheelwright.

In the past, in many of the crafts that were carried on in rural areas, where the needs of the farming community had to be met, there was an inevitable overlapping of skills. This was particularly true of the wheelwright, who had to combine the skills of very advanced carpentry with those of the blacksmith, and add to these ingredients his own particular expertise.

Of all the inventions or discoveries that have ever been made probably the discovery of fire and the invention of the wheel have done more to shape the course of our present civilization than any others. It seems likely that the wheel came about simply by someone observing a log rolling down a slope and realizing the implications of such a thing. Certainly the first wheel must have been solid, with a hole in the middle to facilitate its fixing to the side of some kind of structure. In essence the wheel has changed hardly at all since those early days, and perhaps that is the mark of all truly great discoveries; that they can be refined but never, basically, can they be changed.

The wheels which were the concern of the wheelwright were essentially for horse-drawn vehicles. The coming of tractors and the correspondingly higher speeds that could be attained meant the virtual end of the old farm wagon with its wooden

top left
Dennis Flower at his bench, surrounded by the tools of his trade, involved in making a new spoke for a wheel he is working on.

bottom left
Stripping off the old tyre preparatory to carrying out repairs on a well used wheel that has seen perhaps too many years of use, turning down miles of country lanes.

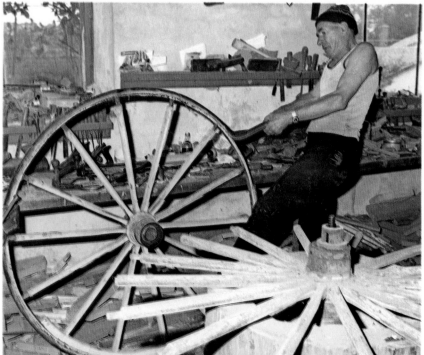

wheels as they were designed for a slower way of life and simply could not take the strain of the faster pace. The present fuel and energy crisis may possibly mean a return to horse drawn vehicles for many purposes and, if this happens, there may even be a renewed demand for the services of the wheelwright.

These days most of the wheelwright's time and expertise is spent on repairing existing wheels, which can often turn out to be an even more involved job than starting a new wheel from scratch! The materials used are the same as they have been for many years; elm for the hub, or stock; oak for the spokes; ash, or in some cases elm, for the felloes, which are the curved sections of wood that go to make up the outer rim of the wheel. The actual tyre, or bond, is of iron and is heated until red hot. It is then forced over the wheel and, when fitted, doused with water. The immediate cooling which ensues, to the accompaniment of great clouds of steam, causes the tyre to contract and thus tighten all the wheels' joints, making a very solid affair of the whole assembly.

Dennis Flower, of Farmborough, in fact retired from active work some three years ago although he finds he is still in demand by local farmers to maintain wheels in good order. Being retired means he can spend more time on such jobs and is able to make such things as plough handles for ploughing competitions, something he never had time to do when he was working full time. He still makes wheels, but now they are in the form of perfect miniatures with an elongated hub to which are attached three legs. With the wheel turned on its side and a round glass top fitted they make very beautiful and unusual small tables! Perhaps he is merely enjoying himself, using all the old skills he has practised all his life, or perhaps he is just keeping his hand in until wooden wheels are once more in great demand!

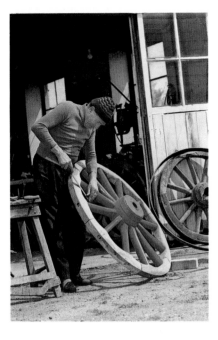

above
Outside his workshop, Dennis Flower adds the final touches to a wheel.

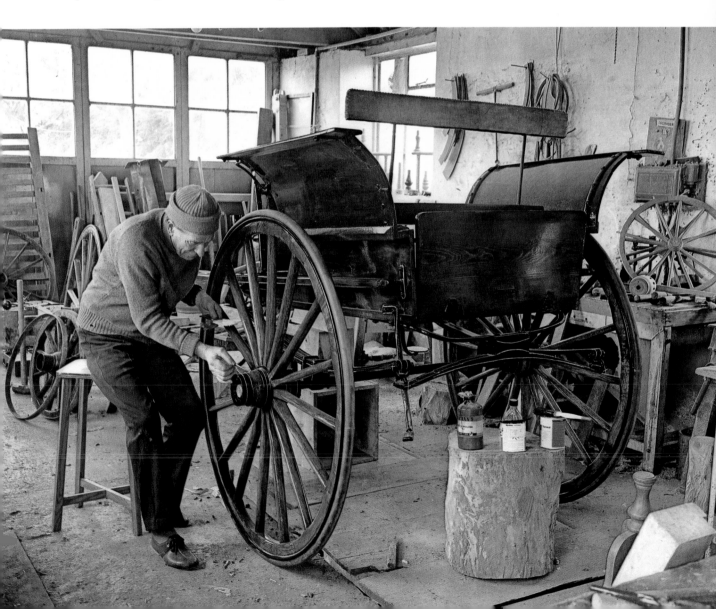

'St Leonard' Fishing Rods.

A great number of anglers in many parts of the world, but most particularly in the United States and, of course, in every corner of the British Isles, have cause to be thankful for the artistry and craftsmanship of Joe Bonham. For forty nine years now he has played a major role in making sure that, if they do not get the maximum pleasure from their pastime, then it is not for the lack of one of the most superbly constructed rods that money can buy.

I watched him adding the finishing touches to another fishing rod, working with the great care and meticulous attention to detail that has established his reputation, and has made him so many friends around the world. He has lectured on his craft, written many articles in magazines devoted to it and has, in fact, been the subject of a television programme made by a continental company. As I watched him, however, I wondered if the television cameras had been able to capture the feeling that comes across as he handles the materials that he uses; a feeling of complete understanding of, and affection for, both the materials and the finished product and, indeed, the use for which they are destined.

Ideally, Joe Bonham likes to see any prospective client before he makes any rods for him. In any event it is essential that he knows the physique, including hand size, and the type of fishing for which the rod is intended, long before he will commence work. Only in this way will he be able to make sure that his customer ends up with exactly the size, weight and balance of rod that will be perfectly suited to him. Of course it is not always a question of making just one rod for a customer. There are many occasions when a collection of rods are ordered, each one specifically designed for a particular purpose, rather in the same way that a golfer needs an assortment of different clubs.

Pride in his workmanship, and the knowledge that he is handing over, when it is completed, a product that meets his own exacting standards, is equalled by the pleasure he gets from

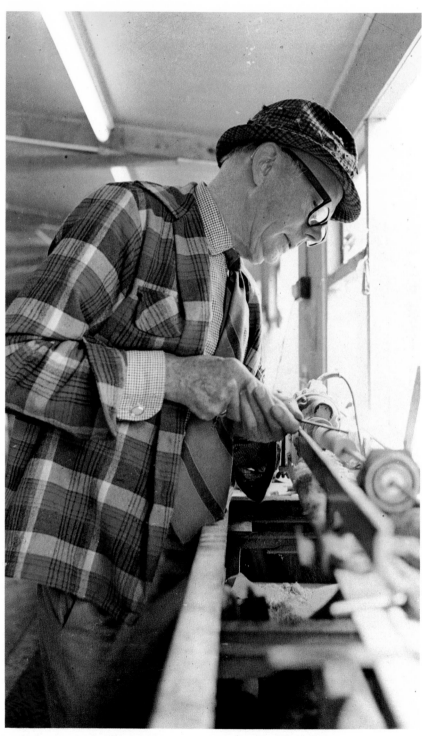

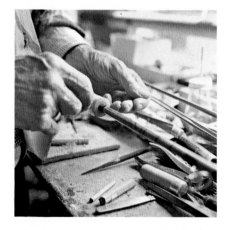

above
Fittings can so easily let the fisherman down, or look sloppy, unless hands as experienced as these whip them firmly into place.

left
Cork rings, fitted together, are roughly shaped, then finally finished on the lathe, to produce a sculpted handle for a St Leonard rod.

the many letters he receives from owners of his rods throughout the world. In addition to being complimentary, these letters are often 'fisherman to fisherman' ones, about fishing in general and about particular catches, many of them even enclosing photographs. It is evident that this particular fraternity imparts a great feeling of belonging, and of comradeship.

There is absolutely no doubt about the person who had the greatest influence on Joe Bonham in his formative years. He still talks with great affection about his grandfather Oliver Roberts and the very special relationship that so obviously existed between them. He stills feels that he has not achieved the perfection in rod making that his grandfather did. This may or may not be so but I can't help feeling that it is a measure of the close bond they had that makes Joe Bonham hold to the belief that this is the case. Certainly it was his grandfather who taught the young Joe carefully to dry out the moisture from the Tonkin bamboo so that the pectin bonded the fibres together, and to split the poles, using only the hardest outer parts to make up the rods. It is equally certain that when he laboured to master the art of whipping the various fitments to the rods, he did it, not only in order to become a master craftsman himself, but also to earn the approval of his grandfather who taught him that, in fishing rod making as in life, there are only two ways to do a thing; the right way and the wrong.

At the moment the order book for St Leonard rods is full, as it has been for so long. The time has come, however, for the book to be closed and, when all the orders in it have been completed, for Joe Bonham to spend his days, apart from still supplying the flies and lures for which he and his wife are justly famous, in just going fishing!

above right
Before starting work on a new rod Joe Bonham, still wearing his beloved old hat, carefully selects a length of seasoned Tonkin bamboo for splitting.
right
The workshop, and the cluttered benches, that have seen the creation of so many fine rods that are used in many different lands throughout the world.

The Miniature World of a Chair Maker.

Stuart King stood in his tiny workshop surrounded by the tools and materials of his craft. The lovely smell of wood was everywhere. There is something warm and comforting about the smell of wood, as there is about so many of the products that are made from it. He was talking about the types of wood he uses and he looked around him and started rummaging around amongst the piles of wood at his feet. He eventually found what he was looking for and showed me what I can only, in honesty, describe as a dirty old piece of wood about two feet long by one foot wide. It was very dark wood and appeared to be riddled with woodworm down one side. He told me that the piece of wood was part of an ancient oak floorboard, probably four hundred years old, and he showed me the original saw marks on the flat sides. He then wet the end grain and rubbed it gently and the dark old colour of the oak showed clearly. It occurred to me that simply to watch Stuart King handle a piece of wood is to understand his affection for the medium he works in. Everything about that old piece of oak was important to him in his insistence that the finished product that eventually finds its way into the hands of its purchaser will be as perfect in every way as he can possibly make it. The sheer beauty of his workmanship would, in fact, ensure that his work would be eagerly sought after but this alone would be by no means satisfactory to him, and satisfaction with the work he has created is all-important to Stuart King and is, I would suggest, the hallmark of the true craftsman.

Selected parts of that particular piece of oak will eventually be incorporated into not a model but a perfect miniature of an Elizabethan chair of estate, standing only a few inches high. It will require no staining in order to have the appearance of a chair of that age, the selection of that old oak will ensure that it only needs

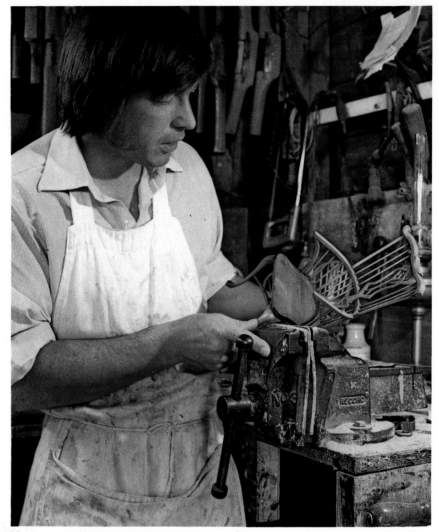

above
Before any piece of furniture leaves Stuart King's hands it is carefully inspected to make sure that it is as perfect as he can make it. The scale, and the intricacy of detail, are easily apparent in these illustrations.

wax polishing to bring out its true colour and texture. The carving on the back of the chair, the curve of the arms and the turning of the legs will all be exquisitely detailed. Turn it over and, on the back, you will see that the saw marks made by the men who cut that floorboard some four hundred years ago, will be there still, carefully retained as one more authentic link with the past. If the saw marks were not original it is doubtful whether anyone would ever know, except of course Stuart King, and that would be very important to him.

I have used the above example in an effort to show the lengths to which Stuart King will go in his search for perfection. The bulk of his work, for which he is so justly renowned, and which makes sure that his order book is full, consists of equally authentic and, to me personally, even more

beautiful Windsor chairs. This may well be because the light, airy design appeals to me more than the rather solid look of the earlier period, and the soft glowing colours of the wood have an immense attraction. There are many different styles of what we know as Windsor chairs, from the most primitive, (the first stage in the development from stool to actual chair) to the lovely Chippendale fanback Windsor and the even more beautiful Gothic Windsor. This particular style is such an obviously outstanding example of the chair makers art that I was not in the least surprised to find that it is extremely rare and greatly prized by collectors. Needless to say, on the Gothic Windsor miniature made by Stuart King, as on the full scale chairs made by earlier craftsmen, the pointed, arched bow at the back is made from one piece of yew, difficult enough in the full size version but quite incredible to see in a quarter scale miniature.

As we talked, about chairs and wood, the history of chair making

and, of equal importance to Stuart King, the tools that the old chair makers used, it was obvious that he is totally immersed in all the many aspects of his craft. He does not, as might possibly be expected, come from a long line of chair or furniture makers, although his father did, in fact, do a considerable amount of work on the furniture of the local church. It is all the more remarkable, therefore, to find that he has only been engaged full time at his present occupation for about three years. His interest, however, goes back many years and even when he was working as a furniture restorer he was busy taking photographs, particularly of chairs, and making measurements and scale drawings, all against the day when he would have his own workshop and be able to devote his days to putting all that he had learnt into practise.

At present he is engaged, in addition to completing the many orders he has outstanding, in enlarging his workshop to enable him to go on to the next stage that he has decided upon; making Windsor chairs that are every bit as perfect as the miniatures that he now makes, but in full size. He has been prevented from doing it up to now by lack of space but the day is not too far off when there will be an eager queue of customers waiting for a genuine Stuart King Windsor chair, made in the traditional way, from traditional materials and, unless I am very much mistaken, made with the same tools that were used many years ago. Stuart King is an avid collector of old woodworking tools and already has an enviable collection. They are not merely kept as collectors pieces however. All the tools are carefully restored and are then used, not just for the pleasure of it, but because they are better, for the particular uses to which he puts them, than any of the implements available today, despite all our supposedly advanced technology!

Lecturing and demonstrating almost forgotten woodworking arts and methods takes up a lot of Stuart King's spare time and he has, in fact, two television appearances to his credit at the present time. As you would expect, all his work is both signed, or rather his name is carved into each piece, and numbered. He feels very strongly about this; that if a craftsman is proud of what he has produced, then he should put his name on it and let the world judge his craftsmanship.

A considerable amount of Stuart King's work is now made for clients abroad, some in Europe but by far the larger number in the United States, particularly in Pennsylvania. This seemed to me quite an extraordinary coincidence, as his workshop is but a few miles away from Penn in Buckinghamshire, the home of William Penn! A lecture tour of the United States would be very much to Stuart King's liking as it is one of his as yet unfulfilled ambitions. At this particular time, with such a resurgence of interest in the traditional crafts, and given his personality, I should imagine such a tour would be a great success.

It is not really possible, in such a relatively short article, to do much more than sketch a brief outline of the man and his work. In respect of the man, however, this is no great problem. He is still quite young and, as his fame spreads (which it most assuredly will) there will be many more words written about him and his fascinating craft.

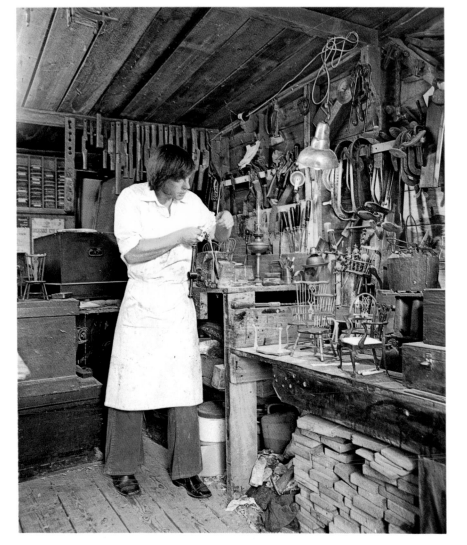

left and below
Stuart King in his workshop. Around him are the many tools of his craft, mostly old, some Victorian, and almost all in daily use.

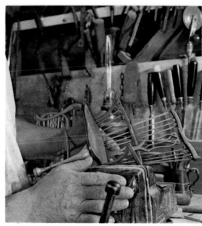

Clubs and Putters.

Outside Laurie Auchterlonie's shop and workshop in St Andrews the rain was drifting across the famous golf course. A few caddies sat on the benches outside the Caddy Master's office waiting to be called. On the first tee a group of Americans dressed in colourful waterproof outfits prepared to play. So strong is the association of St Andrews with the great names of golf that I had been very surprised to find that, in fact, it is a public course and anyone can come along and play on these hallowed greens and fairways.

Inside the workshop our conversation was constantly interrupted by the flow of people, on that particular day Americans mostly, who wanted to discuss some fine point of their game, their clubs, or perhaps just wanted to talk to the man who has come to occupy such a special place in the game. The name of Auchterlonie has long been associated with the game of golf. In 1893 Willie Auchterlonie, Laurie's father, won the Open championship, a fact remembered with great pride by his son. Laurie Auchterlonie was himself a scratch golfer at the age of sixteen and, had he not become so immersed in making golf clubs, would probably have become a professional golfer of great renown.

Of all the superb hand made clubs that Laurie Auchterlonie produces, pride of place must surely be taken by his wooden putters. Whilst other woods can be used, if it is known that an apple tree is available, perhaps because of redevelopment somewhere, then this is eagerly sought as the finest material from which to fashion one of these beautiful clubs. The very best ramshorn, boiled and straightened is inset into the face of the putter, and the back is hollowed to take the molten lead to add the right degree of weight.

At the present time, should someone be thinking of ordering such a putter, they must be prepared to wait for up to three years for its completion! Whether it would improve its owner's putting or not I wouldn't know, but at least he could rest secure in the knowledge that no better is available anywhere.

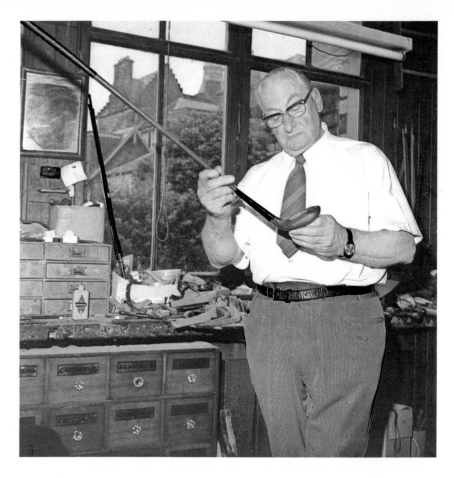

Laurie Auchterlonie holding one of the wooden putters that has made his name famous wherever golf is played.

below
A unique set of miniature golf clubs.

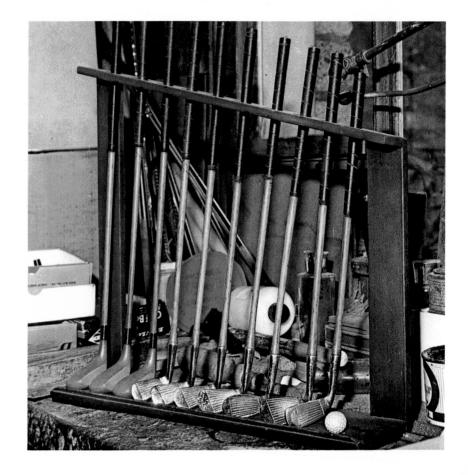

The Cooper's Ancient Craft.

There was a time when a boy would be indentured to a master craftsman for a set number of years so that, by the time he was twenty one, and a man, he would become a craftsman himself and might set himself up in business and in turn train new apprentices. Things have now changed considerably and the practice has almost died out. In the case of coopering it is now some sixteen years since the last apprentices were signed up. To this extent, therefore, it would be quite true to say that the craft is dying; that once the present coopers have finished working at their craft there will be no new ones to come along and take their place. As with many other crafts, the reasons for the demise of coopering are primarily economic. However hard, or fast, traditional coopers worked they could not meet the demand that arose for cheap, long lasting barrels or casks that could so easily be met by modern machinery, producing pressurised metal or plastic kegs in enormous quantities. The arguments that rage, and will continue, about the quality of the contents of modern casks as opposed to the wooden variety are another matter entirely, but it seems rather late in the day for things to change back to what they once were, however desirable it might seem.

Watching a master cooper at work it very quickly becomes apparent why this should be, traditionally, such a difficult craft to master, or in which to attain any degree of proficiency. The work of the cooper is of such antiquity, and has always been so universal that only the very simplest measurements have ever been used, often involving the use of a length of bulrush which could be broken off to the required size, or halved, or divided in some other way to provide uniformity of measurement. It is partly this very simplicity that makes the craft so difficult to master, for a barrel is a very complicated thing to make, and it means that everything must depend on the skill and the eye of the cooper. The other problem is the sheer hard and unremitting work involved. It would be very difficult

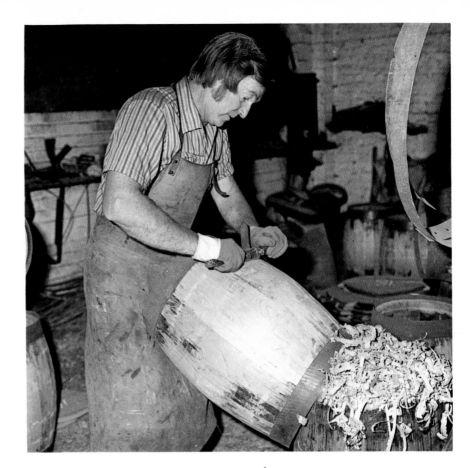

above
Tom Wright at work in his Cooperage in Kingston, Surrey.

to overestimate how physically demanding the work of the cooper can be, and this too has become one of the traditions of the craft.

Oak for barrels is now both difficult to obtain and very expensive. For this reason the greater part of the cooper's time is spent on either repairs or in the production of 'remade' barrels. This re-making is in almost every way just as involved as starting from scratch, the only saving being in the cost of the new wood. It involves taking large barrels to pieces and making smaller ones from the wood. Each stave (the long planks of wood that make up the barrel) has to be cut down and 'dressed' which means hollowing out the inside and cutting away some of the wood on the outside so that it will take, when heated, the right degree of curvature. The stave also has to be tapered towards each end and the sides must be planed at an angle, with quite remarkable accuracy, so that when they are fitted together to make up the shape of the barrel all the mating surfaces will meet perfectly and provide a waterproof container.

In each of the stages up to now, and in those that follow, the bevelling of the ends, cutting the grooves to take the heads, shaping the barrel by heating it over a fire of oak chippings, and driving the hoops over the staves, the eye, skill and experience of the cooper are his only blueprint. It is a great tribute to the skill of the many generations of coopers that this ancient craft should have lasted for so many years, almost up to the present day, and that it should be superseded, not because of any shortcomings on the part of the cooper, but purely because of the demands of our modern society.

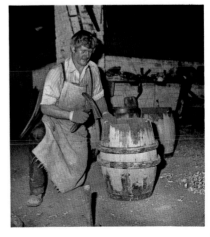

right
The stained glass artist's finished work,
seen in all its beauty in Canterbury
Cathedral.

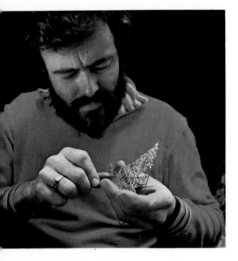

above
Graham Harrow creating a new jewellery
design, in gold, in the Castleward Design
Workshop, at Strangford, Co. Down,
Northern Ireland.

right
Suzanne Loftus Brigham adding the
finishing touches to one of her famous
'Parlour Mice' designs.

below
Busy machinery receiving attention at
Newalls Tweed Mills, Stornoway, Isle of
Lewis, Scotland.

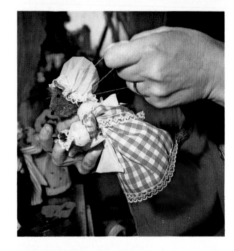

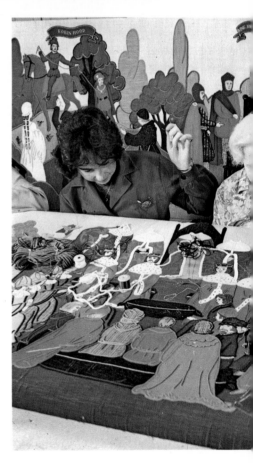

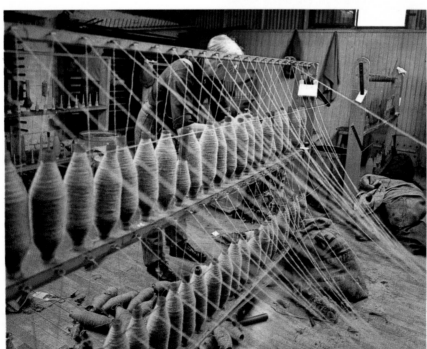

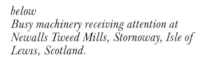

above
Work in progress on the famous Hastings
Historical Embroidery at the Royal School
of Needlework in Kensington, London.

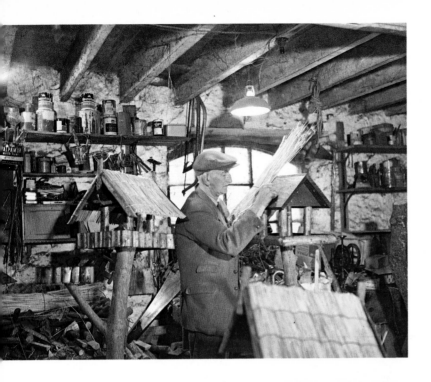

left
Archie Harris thatching a bird house at Blagdon in Somerset.

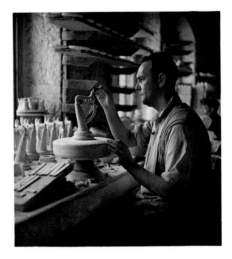

above
A craftsman at work on a harp made in pottery at the Belleek Pottery in Co. Fermanagh, Northern Ireland.

below
The famous full size replica of the 'Golden Hind' under construction using traditional tools and methods at J. Hinks's Shipyard at Appledore, North Devon.

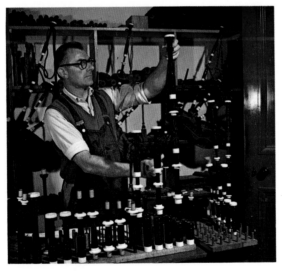

above
In the workshops of Hugh McPherson in Edinburgh, Scotland, a set of bagpipes nears completion.

below
Continuing the ancient and time honoured craft of coracle making in Wales.

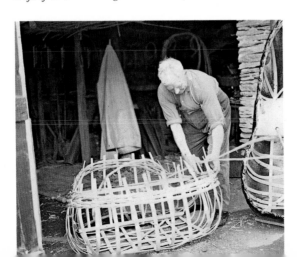

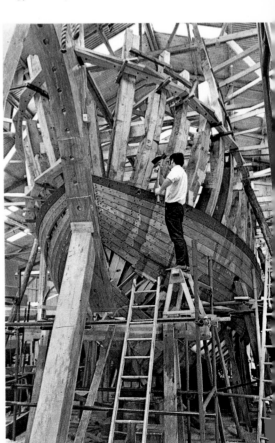

The Shoemaker.

Whatever the fashion may be at a particular moment most people want to feel part of it. There must have been a time when clothing was bought, or made, for its practical value only; how warm it kept the wearer and how dry; how long it lasted and how much ease of movement it allowed. These days are long past and we now wear quite a considerable amount of clothing that is quite unsuitable for most purposes other than being in the fashion. Of none of the clothing we wear can the foregoing be said to be truer than it is of footwear. When we think about

With this in mind I found it quite intriguing to visit one of the oldest established hand made footwear makers in London–John Lobb of St James. There is no question of calling here and trying on a pair of shoes and buying them. Feet are treated almost reverently in such a place as this, and rightly so.

Measurements are first taken, either from the foot or from a well worn, comfortable, and well fitting shoe. These measurements are then interpreted by a well trained 'fitter' who takes into account the many variables in posture and walking habits that either the shoe or foot can tell him. Upon the expertise of the fitter depends much of the success of the final article. From his work a last is made, usually from Hornbeam, Beech or Maple. After the shoes have been completed these lasts will join

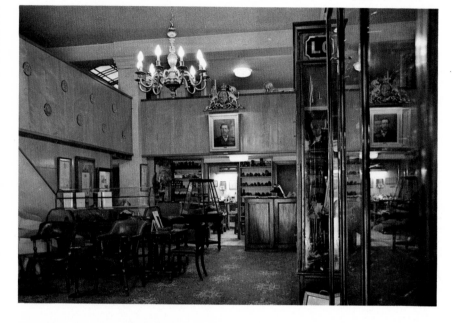

left
The impressive interior of the premises fits exactly what would be expected in an establishment with such a history and reputation.

below
Quality control. Uppers being checked before the soles are attached.

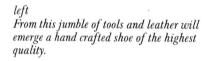

left
From this jumble of tools and leather will emerge a hand crafted shoe of the highest quality.

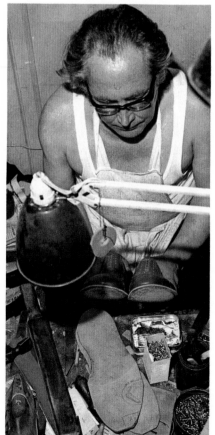

it, we really must admit that we do abuse our feet! Long pointed shoes, high platform soles, tight laces, shoes that slop up and down as we walk; as we go through life we stick them all on our feet, and wonder that they protest.

Not long ago I was told of a man who parked his Rolls-Royce outside the premises of a shoemaker. He hobbled, on obviously painful feet, into the shop and asked the shoemaker how much he would charge to make a pair of shoes. When he was told the price he stepped back and, remarking that he would never spend such a sum on a pair of shoes, he hobbled out of the shoemakers and climbed back into his Rolls! The story may well be apochryphal but it does indicate how many of us regard our feet and what we wear on them.

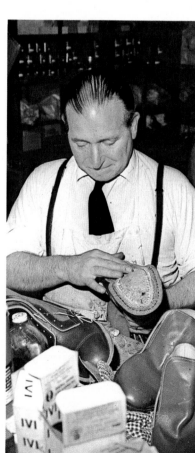

the many thousands of others, all carefully labelled with the customer's name, which are stored in seeming endless racks in the basement. From the lasts paper patterns are cut and the 'closer' then uses these patterns to cut the shapes of the leather that will form the upper. He then sews the pieces together, including all the stiffeners and linings, constantly returning to the last to ensure that the fit is perfect. The 'maker' now completes the shoe by attaching the sole and heel. It is at this point that 'lasting'–drawing all parts of the upper taut and close to the wood of the last–takes place. The only remaining stages are the punching of the eyelet holes and the polishing of the dressed leather.

It all sounds so easy. The final result will be a perfectly fitting shoe that, whilst new, will feel like the most comfortable old shoes the owner possesses. All this will have been brought about by the high skill and craftsmanship of everyone concerned, at every stage of the construction of the shoes, and they will have built into them that indefinable 'something' that is impossible to describe but which is obvious to the wearer as it always separates the excellent from the merely good.

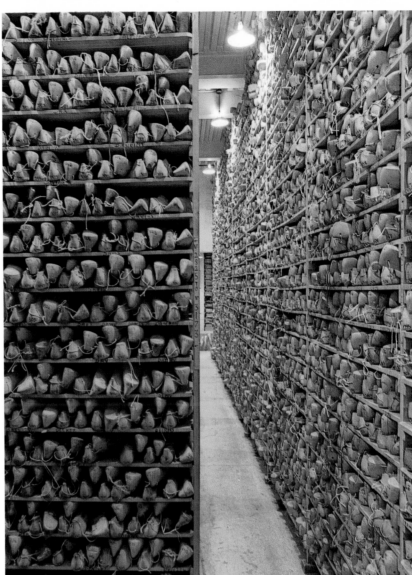

right
Just a few of the many thousands of lasts stored in the basements.

below
This ancient and fearsome looking instrument, used to shape the lasts, is capable of great delicacy and precision.

below right
All the tools and materials are kept very much to hand!

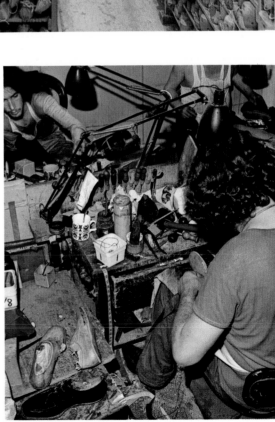

The Magic of the Keyboard.

It is surprising the way a keyboard, usually of a piano, quite often proves to be an almost irresistible challenge, particularly to those of us who have no musical talent and can play no instrument! There seems to be something about the gleaming white keys, interspersed with black, that makes those of us who cannot play want to try! This particular thought came back to me when I visited the Morley Galleries in Lewisham, and found myself surrounded by all the very beautiful harpsichords, clavichords, spinets and pianos that fill every room.

I was being shown the various instruments by Mr Austin prior to taking some photographs in the Galleries and following a visit to the Morley workshops where I had seen similar instruments being constructed. The name of Morley has been connected with music and musical instruments in one form or another for over three hundred and fifty years, the family having established themselves as musical instrument makers in the City of London in Regency times. Their works are now situated in Bromley and it is there that they produce the hand built clavichords, harpsichords − both single and double manual, virginals and spinets as well as the 'Aeolian' wind harp and the 'Clarsach' Irish harp. With such an assortment of instruments, with names that seem to come from another age, I should not have been surprised to find only very old craftsmen engaged, almost as the last of their line, in their production. I was very pleased to discover that such is not the case. There are, of course, craftsmen working there who have spent the whole of their working lives with the company and are on the threshold of retirement. Working side by side with them, however, are many younger

left
One of the Morley craftsmen building the frame of a spinet.

below left
A similar stage in the construction of the frame of an instrument. This time it is a harpsichord that is being built.

below
For holding together, under pressure, large pieces of glued wood until they are set, no better method has been found that can successfully replace the traditional, and extremely practical, use of 'Go Bars', which are of particular value in fixing the sound bar to the sound board.

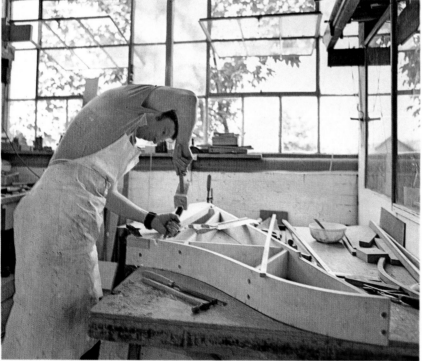

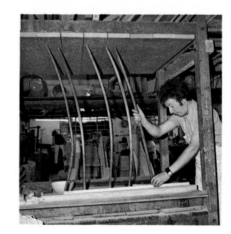

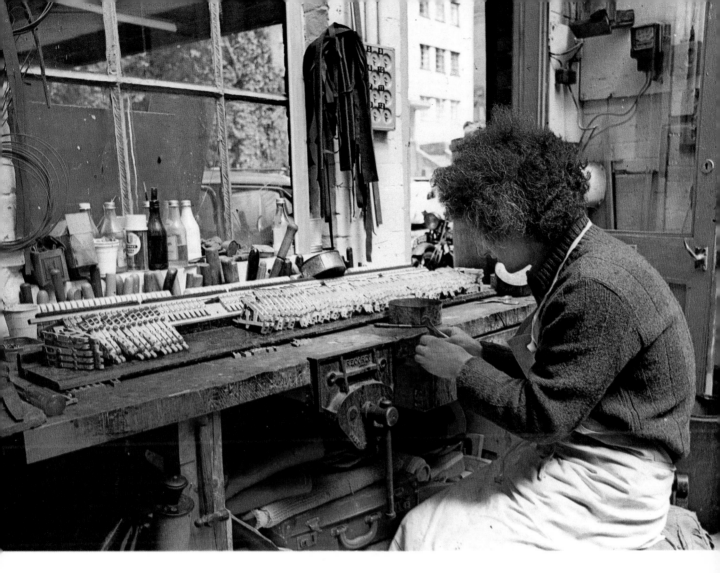

men, ready and able to carry on the traditions of fine craftsmanship, and this they are doing, with great success.

There is nothing of an assembly line nature to be seen at the Morley workshops. Indeed there is probably much that would cause a time and motion expert to throw up his hands in horror, but then true craftsmen are seldom interested in finding ways of doing a job quicker, they would rather spend their time in trying to do it better! Obviously, with the orders they have to complete, production must have some importance but, watching the various stages in the manufacture of new instruments and the restoration of old ones, there is no doubt at all that the prime consideration is that the best possible product should be made rather than that a deadline should be met.

The piano will probably always be the most popular of all the keyboard instruments. Nevertheless, there is now, apparently, an enormous renewal of interest in the early types of instrument and, particularly

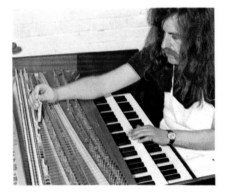

above
A high degree of skill and expeience is necessary in adjusting and fitting the 'jacks'. A double manual harpsichord is the instrument that is here undergoing the process known as 'voicing'.

top
Restoration work being carried out on a piano. In this illustration attention is being given to the 'action' or mechanism.

right
A finely decorated 'Bach' clavichord. Hand built in the Morley workshops and now on view in the galleries.

in the clavichord. On the practical side this is easy to understand. The clavichord is small enough to fit into virtually any room and can, with the legs removed, quite easily be carried on the back seat of the average car. Quite apart from such considerations, the gentle haunting sound that it produces has a magic that is very hard to resist. When the pleasure that such an instrument can provide is coupled with the fine craftsmanship that is so obvious in its construction then there is little wonder at its deservedly increasing popularity.

Pipe Makers.

Ever since Sir Walter Raleigh returned from one of his many travels and introduced tobacco into this country pipes of one sort or another have been manufactured here. A number of early pipes were fashioned in silver which was, of course, expensive, but then so was the tobacco which had to be brought from the Americas. It was not long before tobacco smoking become increasingly popular and there was soon a demand for a cheaper pipe that poorer people could afford. Clay, as a material for pipe making, was an obvious alternative. Potteries already existed, the clay was cheap enough, and the kilns for firing it were readily available. As the demand for cheap pipes increased manufacturers started to cater exclusively for it and there was soon a thriving industry devoted to the craft of pipe making. Pipes became more sophisticated, long stems were used to assist in the cooling of the tobacco smoke, and the bowls of the more expensive pipes were decorated with more and more intricate designs. Despite the relative cheapness, particularly of the simpler styles, all the clay pipes that were made had the same serious drawback; they broke far too easily. As the older the pipe became, and the more it was smoked, the sweeter it tasted this was obviously a source of great irritation. Nevertheless they remained as the standard method of smoking until the latter half of the nineteenth century. It was at this time that two things happened within a short space of time which meant the end of the large scale manufacture of clay pipes. The first was the introduction of the cigarette as a handy means of tobacco smoking, and the second, which followed shortly after, was the manufacture of pipes made from the root of the briar. Clay pipe making gradually declined to the point where, now, only a very few people are still continuing to make them.

The briar from which pipes are now commonly manufactured is in fact the root of a species of heather which is found in the area of the Mediterranean. At one time plentiful, it is now becoming scarcer all the time, due to the ever increasing demand for good quality briar for pipe making. The problem, as with most other natural resources, is that it takes far longer to produce than it does to harvest and so an ever decreasing supply becomes inevitable. The supply problem is, unfortunately, magnified enormously by the wastage that occurs once the briar has been gathered. This is in no way the fault of the pipemaker or his operators, but is the price that has to be paid for working with a natural material and setting such high standards for the finished article.

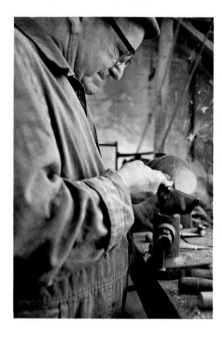

above
One day a connoisseur will cherish the pipe slowly taking shape in the lathe.

From the moment the diggers fell the trees the process of rejection begins. A great deal of the root may by chopped away because it is found to be rotten or has obvious cracks in it, and from a large root it may well be that only a small proportion of it is worth sending to the next stage, which is the cutting of the apparently good wood into roughly shaped chunks, from each of which, hopefully, a pipe will be made. As soon as the pieces are cut they are examined and the rejection continues. Eventually the blocks of root that remain are shipped off to pipemakers, where the process of acceptance or rejection continues.

To a great number of pipe smokers throughout the world the name of the manufacturer, which is stamped into the stem of each pipe, is all important. After visiting two such manufacturers, Alfred Dunhill Ltd., and Charatan Pipes, both in London, I was left in no doubt that the name, and the reputation that goes with it, is of equal if not greater importance to the people responsible for making the pipes. In both these companies I saw pipes being rejected, in many cases by the operators themselves, at each and every stage of their manufacture. Even pipes that had survived to the point of having the name stamped into them were turned aside; some to be sent back to have more work done on them, some to be totally rejected and scrapped. There is no doubt that this insistence on a flawless final product is what makes such pipes seem relatively expensive; this and the amount of individual craftsmanship that has to go into the making of them. No matter how many machines may be used they can only do the preliminary work and, in fact, the only real purpose they have is to make such work quicker in order to keep the cost as low as possible. At one point, watching pipe bowls being roughly turned on specially designed machines at the Dunhill works, I was struck by the thought that perhaps the most valuable contribution that such machines were making was that the flaws were discovered rather more quickly than they would be if they were shaped to this extent by hand! After this initial shaping the few bowls that pass inspection are sanded and pumiced by hand to start to bring out the natural beauty and grain of the wood. Both these processes are very critical for, if too little or too much is done, a bowl that had been considered 'clean' until that point can be spoilt and join the ever grow-

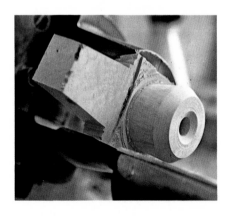

above
The familiar shape of the bowl emerges.

ing percentage of rejects. The survivors still have to go through the staining and polishing sections as well as having their vulcanite mouthpieces fitted, each of which has to be individually shaped to fit the particular bowl it is made for, before being inspected and stamped with the manufacturers name.

Even today, not all pipes are even roughly shaped by machine. At Charatan Pipes I watched Dan, who has been making pipes for fifty-nine years, selecting a piece of briar. After considering several such pieces he found one to his liking and, after roughly shaping it by saw, he put it into his lathe and started work on it. The shape that gradually emerged was entirely of his choice and depended on the size and the grain of the wood he had selected and his own artistry and craftsmanship.

In some ways I think pipe making can be likened to pearl fishing. In both cases it is not known, until the outer covering is stripped away, whether anything of great beauty is contained within. I was most interested to learn therefore that, as the pearl fisherman hopes, once every so often, to open a shell and find a pearl of such outstanding beauty that it puts others to shame, so the pipe maker is always looking for the perfect grain in the wood he works with.

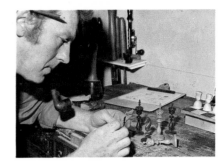

To a pipemaker this would be perfect straight grain. Such pipes are, of course, made and, providing there are no flaws, the resulting pipe becomes a highly priced, top of the line product. Once every year or two, however, a really outstanding. piece of root may be discovered in which the grain is perfectly straight and parallel over the whole of its length. This means that, again providing the wood is equally suitable in every other respect, a pipe may be fashioned in which this grain will be seen running from top to bottom of the bowl and all the way along the stem. It is essential that the potential in such a straight grained piece of wood is spotted very early in the manufacturing process, when the root is first sawn to rough shape, as it will immediately be taken out of the normal run and there will be earnest discussion on the best ways to exploit its unique qualities. Many weeks of careful and painstaking work will go into the making and polishing of the pipe that is eventually made and it will be handled, at every stage, with something akin to reverence. To the connoisseur, however, it will all be worth while and the value of such a pipe may well be measured in four figures. Whatever its worth in terms of money, it will certainly be a tribute to the skill and care which the craftsmen have lavished upon it.

below
Meticulous final inspection.

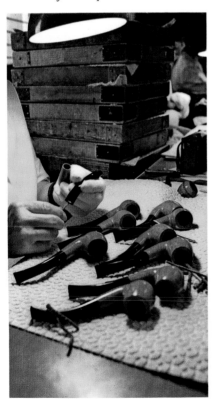

Kings, Queens, Knights and Pawns.

Of all the board games that have been invented and played since the dawn of civilization, surely none has matched the game of Chess for universal appeal. It cuts across all barriers. Language differences are no problem and the rules are pretty well as universal as the game itself. For those who play chess the possibility exists for them to find a chess club, and an opponent to play, almost anywhere in the world.

Given such a long history of popularity it is not surprising that there have been, over the years, many hundreds of different styles of chess pieces. Some have been relatively simple but others have been of such elaborate construction as to make playing almost impossible because of the distraction they caused.

The standard design of chess pieces is known as the Staunton set and, whilst most players possess such a set they often become interested in other designs, some to play with and others to collect for their own sake.

Catering very much for individual chess enthusiasts is Anthony Archer, of Ixworth in Suffolk. He produces hand made chess sets and no two sets are ever the same. He has made large, very elaborate pieces and small, seemingly simple, but very intricately fashioned sets as well as modern sets that have the look of functional sculpture about them. As you would expect, whatever their design, whether modern or traditional, they all share the unmistakable mark of the true craftsman – superb workmanship.

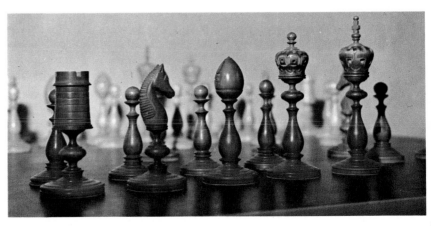

Corn Dollies of Suffolk.

Royston Gage was born in the old farmhouse just down the hill from where he now lives with his wife Winifred. When he was a little boy he used to watch his grandfather, when the harvest was in, pass the time by making corn dollies. At this time the craft had almost ceased to exist to any real extent although a few churches were still decorated at harvest time.

Having learned a little of the craft from his grandfather, Royston found a farm worker in the village who was able to teach him some of the traditional designs. His interest in the craft and its history grew with the passing years and when he married he continued, with his wife, with his hobby of corn dolly making. The hobby has now progressed to the point where a great deal of their time is now spent in supplying a constantly growing demand for their work. They are still able, just, to cope with the demand by themselves, and this is the way they would like to continue if possible. The problem is that, from being an almost forgotten art, it has now become extremely popular once more, as have so many other rural crafts, and their work is much sought after by people looking for the genuine article.

The making of these fascinating creations has been going on for many thousands of years. They were most probably first made in the Nile valley in Egypt, where land was first cultivated. Certainly there is evidence of them to be found in ancient tomb paintings from the area. The local people, who depended for their livelihood on the germination of the corn seeds and their eventual harvesting, worshipped a corn goddess. At the end of each gathering of the harvest, fearful that the spirit of the goddess would leave, or die, if all the corn was thrashed, they saved the last of the corn intact all through the winter until the following spring, when the new seeds were sown. At the time of the new sowing a ceremony took place, at which the corn that had been saved was burned, or buried, as an offering to the goddess they worshipped. It was hardly surprising that, instead of simply saving the corn as

it was, they would fashion it into something that would be a reminder of their deity. As land cultivation spread, so did the practise of the worship of the goddess and its attendant ceremonies. In Rome this goddess took the form of Ceres and, as with many other of the Roman gods and goddesses, she was imported into this country at the time of the Roman occupation. Happily, she remains with us to this day in one form or another.

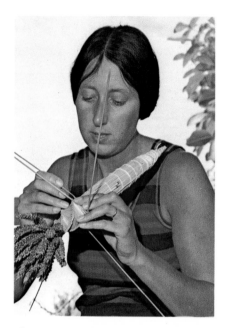

above
A traditional corn dolly nears completion. The speed of construction is surprising, and looks easy until you try!

The making of corn dollies is, of course, no longer a matter of religious observance and so they take many forms. What has survived intact is the actual art of making a variety of shapes by bending and interlocking lengths of straw to create the three dimensional figures. I have seen models of the Concorde, a Boeing 707, a windmill and various other fanciful designs, but they all had one thing in common; they were all made in the same way that corn dollies have always been made. Quite apart from such modern designs there is enormous variety in corn dollies from one corn growing county to another. The designs have presumably been elaborated through the years and they now range from the long twisted spiral, rather in the shape of a very long cigar, with the ears of the wheat kept intact and splayed out at the end, which has come to be known as the traditional corn dolly, to the extremely elab-

orate construction known as the Lincolnshire Fly-Catcher.

The evolution of commercially viable wheat, with new strains being introduced which have shorter stalks and larger heads, has produced a crop which is no longer suitable for dolly making. The craft demands that a long, hollow straw be used and this has led to old varieties being planted again for use by the corn dolly makers and, incidentally, by thatchers. It is essential that the wheat is not damaged in any way and so it is either gathered by hand after being cut with a scythe, or, as is the case with Royston and Winifred Gage's crop, an old type of binder is used. After careful drying the wheat is put to one side until it is needed. At that time it has to be dampened again to achieve just the right amount of pliability. Too dry and it will break–too damp and it will bend, making it impossible to create the right rigidity in the finished work. When a new length of straw has to be joined onto the work in progress this is done by pushing the end of the new piece into the end of the old; hence the need for hollow straw of a quality that will not split either during this operation or during the sharp bending that the material is subjected to. It may be thought that articles made from such material would be very fragile and short lived. This is not so however, and to prove the point Royston Gage showed me various pieces that he has in his possession. Two basket-like constructions were known to be well over eighty years old and a third was thought to have been made in the middle of the last century.

To anyone interested in old crafts their revival from near extinction is a matter of great satisfaction. Fortunately it would seem that the future of the craft of corn dolly making is assured, although this will, as in all things, depend to a great extent on the continuance of public interest and demand. At the moment both interest and demand are high; so high in fact that because of the number of times they are asked to demonstrate their craft, the Gages have recently introduced a kit consisting of the correct materials and full instructions on the making of a corn dolly. They hope that by interesting more and more people in this ancient art form, and by giving them proper instruction, they will ensure its continuing growth as a hobby.

The Potter's Wheel.

Of all the rural crafts pottery must surely rank as one of the most ancient. Since time immemorial man has needed containers in which to place all manner of things, not only liquids but even documents, as witnessed by the finding of the Dead Sea Scrolls in pottery jars. As with fire, the origins of pottery are lost in antiquity. It seems reasonable however, that someone somewhere discovered, probably by accident, that when the crudely fashioned containers that had been kneaded from clay were left near a fire they became very much hardened, far more so than when they were simply left to dry in the sun. From such simple beginnings evolved the enormous pottery industry that exists today, as well as the high art-form that is within the achievements of pottery.

It may be imagined that, with the growth of mass production methods, the individual potter would be a member of a dying craft. So far as everyday utility articles are concerned this may well be true, but a look through any of the craft directories will soon show that there are still an enormous number of small potteries to be found. At the present time there is an increasing upsurge of interest in genuine hand made articles, and the work of the potter is no exception to this trend. With mass produced articles, however skilfully they may be made, there is, somehow, an impersonal quality evident, whereas with hand made pottery there is an immediate and obvious contact, through the work, with the craftsman who made it. Perhaps this is why the work of the most highly regarded potters appears less finished; maybe the fact that, seemingly, as little as possible has been done to the original clay, that it still bears the marks of the potter's hands, that the material has become what it now is without changing its basic qualities too much is the secret of, for instance, the great Japanese masters.

Evening classes in pottery are invariably well subscribed. There is hardly any theory to be mastered

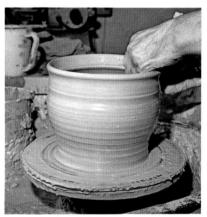

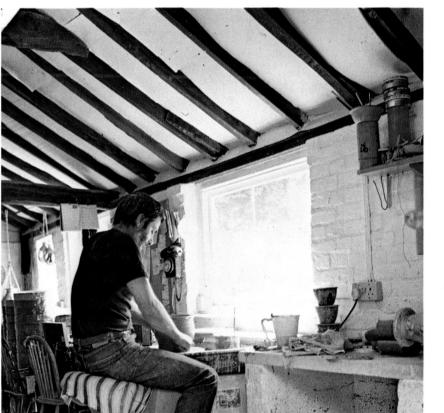

left and above
Bob Tarling at work in his pottery in Kersey, Suffolk. There is a peaceful fascination in watching as the beauty and symmetry of the pot emerges from the wet clay in the potter's hands.

and it probably takes most of us back to our childhood when we loved playing with mud and making all sorts of shapes out of modelling clay. The potter's wheel, the wet clay, the feeling that with our own hands we are fashioning something, however crude, brings its own sense of achievement. The difference between our efforts and those of an accomplished potter are enormous. Nevertheless, unlike things mechanical or electronic, we do at least understand how the thing is done and the only marvel is in the skill and dexterity, the craftsmanship, in the potter's hands that enables him to transform a piece of common clay into a functional and beautiful object.

Glass Engraving.

Patrick Heriz-Smith has been involved in many different art forms all his life. His first and abiding love has always been drawing however. Drawing is a very exacting art form, for so much depends on the beauty and expressive quality of line that it is extremely difficult to hide any imperfections. Twenty years ago he decided to try glass engraving and he has been engrossed in it ever since. Over the years he has developed his own methods and tools to suit the particular way he likes to work and the subjects he likes to work from. In fact, the materials and tools that are required are minimal. The object that is to be engraved, perhaps a decanter or bowl, must be of the finest quality lead crystal which is soft enough to be worked on with the tungsten-carbide tipped needle, of incredible sharpness, that is used for the actual engraving. A piece of black velvet on which to rest the glass and against which the design will show up, and a small lamp with a directional beam placed close to the work to illuminate the working surface, and that's about all. As someone once said about painting–'there is really very little to it, it's simply a matter of putting the right colour paint in the right place'! The same is true of glass engraving. The only additional ingredients required are supreme skill, infinite patience and years of experience.

The production of an engraved work starts with a drawing of the proposed design. This is then approved by the client after which it is transferred to the glass by means of stippling with the tungsten-carbide needle. No lines are used at all. The whole effect is created by engraving minute dots into the surface of the glass. On the grouping of the dots, either close together or further apart, depends the impression of light or shade that is created by light falling on the tiny indentations. As may be imagined, quite apart from the skill required, the time taken to produce an engraved work in this way is very considerable and is a

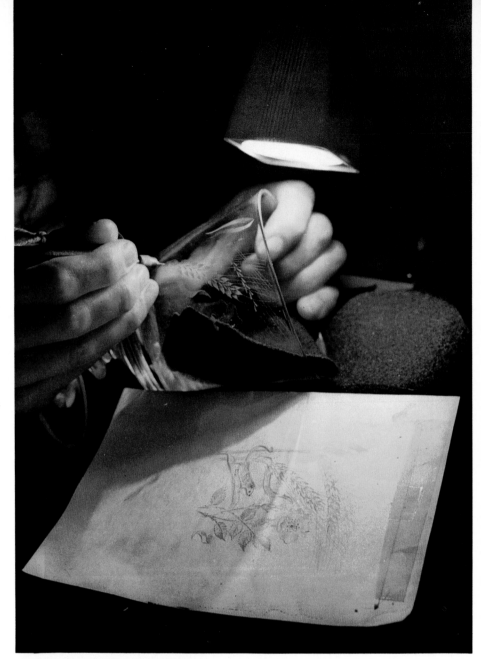

above and left
The world of the glass engraver is a world of concentration. There can be no mistakes made in work as fine and detailed as this.

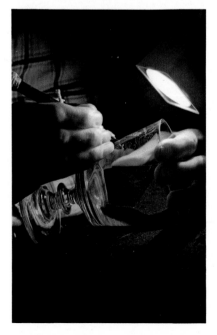

governing factor in the amount of work that can be accepted. Patrick Heriz-Smith has, at the moment, enough work to keep him fully occupied for a year. He turns down very large commissions for the simple reason that they would be so expensive as to make them out of reach of all but the wealthy, and this is something he is determined should not happen. He wants his work to be affordable by the many rather than the few. This ideal is something that seems, to me, to be very much in the best traditions of craftsmanship and is an ideal that is shared by many true craftsmen.

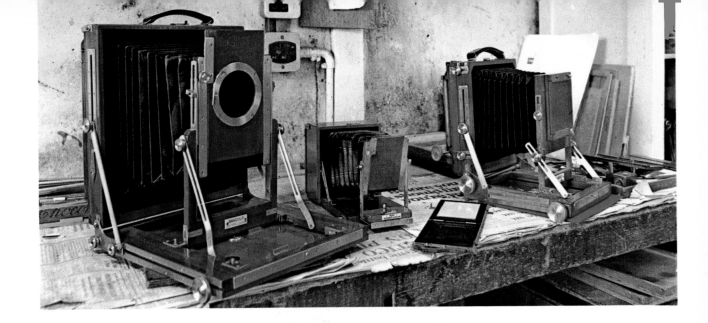

Gandolfi Cameras.

To call a product 'the best in the world' is usually considered to come under the heading of 'sweeping statements'. In the case of the cameras made by the Gandolfi brothers Frederick and Arthur, however, I would certainly not be the first to describe them as such and it seems to me to be a fair assessment of their product. I cannot imagine that many other manufacturers would have orders for their cameras from people who were not, and had no intention of becoming, photographers but simply wanted to own a unique and superbly crafted camera for its own sake, yet such is certainly the case with the Gandolfi's instruments.

Quite apart from their intrinsic

above right
Fred Gandolfi and, below, Arthur
Gandolfi in their Peckham workshop.

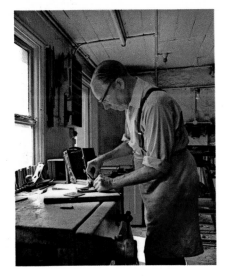

top
Three Gandolfi cameras covering over sixty years. Left, a 1/1 'Imperial' made by Louis Gandolfi in 1911. Centre, a 3½" × 2½" hand camera built by Fred Gandolfi as an apprentice of seventeen. Right, a 5" × 4" 'Precision' teak brassbound camera made in 1971 by Fred Gandolfi.

value, the cameras that the Gandolfi's make are working instruments of the very highest class. If they were made from less beautiful materials than Spanish mahogany, Honduras mahogany, teak and hand cut and lacquered brass fittings, they would still work every bit as well, but this is not the way of the little company that started in a shed behind a shop in the Old Kent Road in the 1880's. The fact that the cameras work superbly well because they are soundly designed and practical instruments is taken for granted. What separates these particular cameras from any others now being made is that each one is an individually crafted masterpiece from start to finish. There are no mass production methods here. Each piece of wood is hand planed and finished and then matched, even for quality of grain, to its fellow pieces before any joining of any sort takes place. French polishing by

hand, countersinking of brass screws to exact matching depths, even lining up the slots in the heads of the screws, is the way things are done in the Gandolfi works at Peckham. There can be no question of hurrying to finish a camera, nor are there any stocks of completed instruments you can buy. If you want a Gandolfi camera, then you will have to be prepared for a long wait; probably two years or more!

Neither Frederick Gandolfi nor his brother Arthur are young men any more. The sad fact is that, whilst they hope to continue until 1980, in order to complete the family centenary, after that date there will be no more Gandolfi cameras. The thing that sticks most in my mind about my visit was something that Fred Gandolfi said just before I left. He told me that now that they were easing up, and the pressure of proving themselves no longer existed, they were able to spend even more time on each camera to ensure that they were even more superbly finished than ever before!

If anyone ever asks me to tell them where all that is best in the ideals and execution of true craftsmanship may be seen–I shall direct them to Peckham Rye!

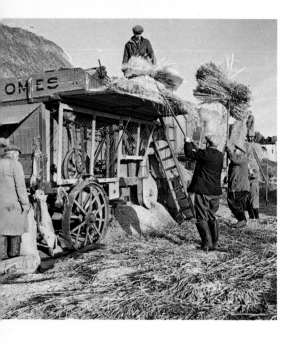

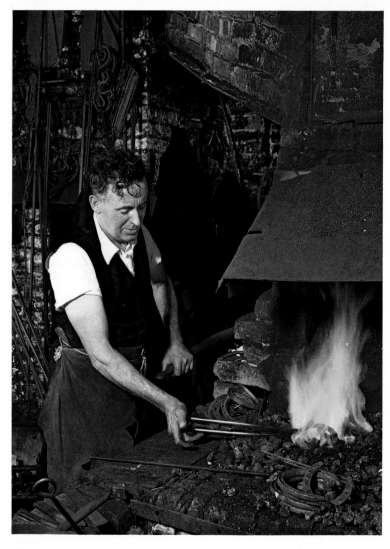

above
An old fashioned threshing machine, very few of which remain in operation, at work in the fields at Coggleshall in Essex.

below
In the cider county of Somerset, at Wedmore, an old cider press being used to crush the apples between layers of straw, in order to extract the juice which flows into the wooden tub below.

above
The farrier at work, fashioning a horse shoe in his forge.

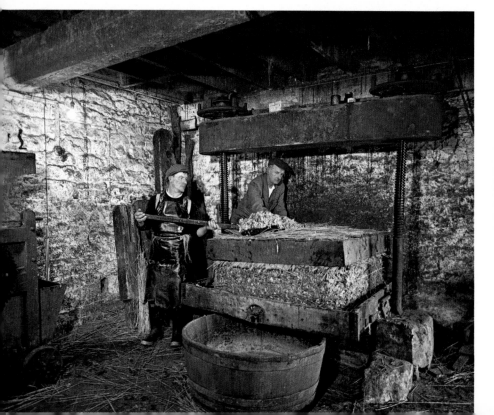

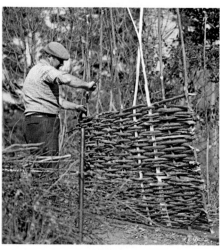

above
'Hurdles' used for sheep penning being made in the time-honoured way at Briants Puddle in Dorset.

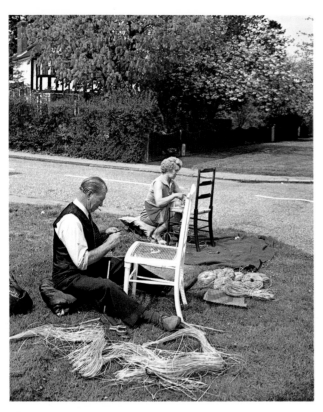

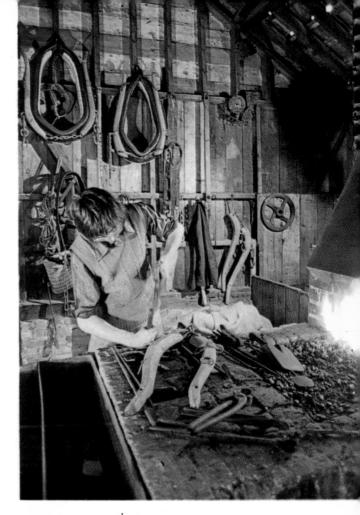

above
Wicker chairs being 're-seated' by the
roadside at Shalford in Surrey.

below
A horse shoe being fitted by the farrier.

above
In a Smithy in Suffolk a young craftsman
carries on the traditional method of making
horse collars.

below
An old craftsman constructing a basket in
the Aran Islands, off the coast of Ireland.

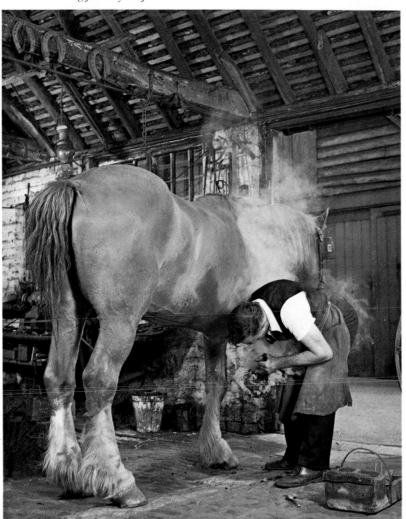

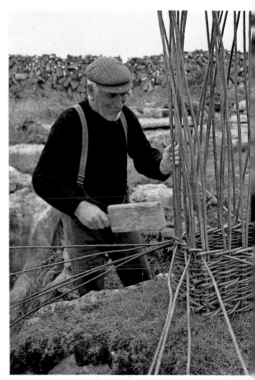

Violas, Violins and Cellos.

As I walked up the path towards the workshop in the little Wiltshire village where Julian Emery has made his home, I could hear the strains of Beethoven's Violin Concerto in D Major. Since I was about to interview and photograph a violin maker I thought that it was an extraordinary coincidence and was perhaps something especially laid on for my benefit. In fact, coincidence is all that it was, for the music was coming from the radio in the workshop and not from a record. Nevertheless, the atmosphere and setting could hardly have been more appropriate.

As everyone will know, a violin, viola or cello is basically a curvilinear resonant box, across which strings are stretched. What may not be so apparent is that the shape of the violin is not just something that is pleasing to look at. It is a shape that

below and right.
Julian Emery at work in his Wiltshire workshop.

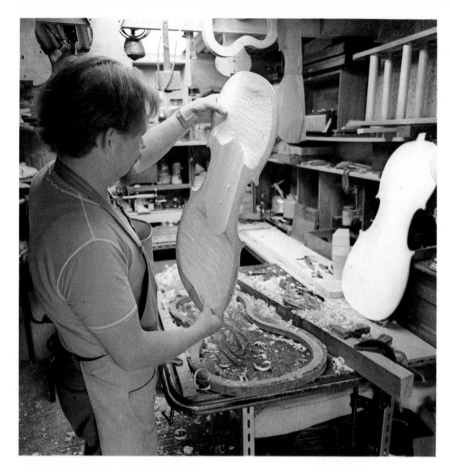

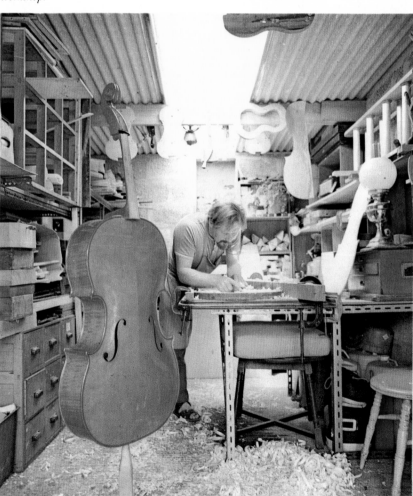

has evolved over hundreds of years and is entirely functional. In fact, the only non-functional part of a violin is the scroll work at the very end of the neck. The whole process of making a violin is an incredibly complicated one. Not only must it look right and be superbly constructed and finished; it must also be immensely strong to withstand the stresses of the tightened strings and, of course, it must sound right.

The wood for violin making, spruce for the front, maple for the back, and either maple or sycamore for the neck, has to be selected with extreme care. It must be naturally seasoned, not kiln dried, and is bought as much for its acoustic properties as for its appearance. I trust I am not alone in having imagined, before I visited Julian Emery, that the shape of the violin body was cut out and was then pressed in some way to give it its final undulating form. As it turns out, this is about as far from the actual method as may be imagined. After cutting out the basic flat shape, of either the front or back, it is placed in a special jig on the bench and wood is planed away, using planes specially designed for the purpose, the smallest of which, in brass, measuring some-

thing under an inch in length, until the familiar sculpted form of the violin body emerges. Once this is done it is turned over and the operation is repeated on the other side–but in reverse! This process continues until exactly the right thickness of wood is left. Frequent measurements are taken and a stethoscope is used to listen to the resonance as the carved wood is tapped. Careful planing continues, always bearing in mind that, whilst more wood can be cut away, if too much is done it cannot be put back, until the violin maker is satisfied. The rest of the work is equally exacting, requiring craftsmanship of the highest order which can best be understood by examining an instrument. Little would be achieved by trying to give a step by step commentary on the construction of a violin but the method of shaping the front and back sections is something I feel must be quite unique to this particular craft and well worthy of description.

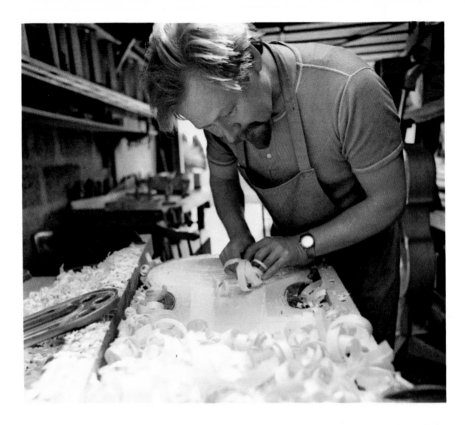

Stringed instruments, their construction and the music that can be played on them, form a large part of Julian Emery's life. He studied the violin before taking up their making as a hobby and then spent some time repairing them before deciding to devote all his time to their construction. He is constantly seeking ways to improve violins and violin making generally and feels very strongly that such efforts should continue. He has no time for those who buy old violins merely because they are old and are seen as an investment rather than for their playing qualities, and feels that this, the quality of sound it can produce, should be the main basis on which a violin should be judged. One of the many problems in gaining any sort of reputation in Julian Emery's chosen profession is the time taken to produce each instrument. All orders for instruments are invariably the result of recommendations and so it is an obviously lengthy process. That Julian Emery is so well regarded at the age he has reached is some indication of his skill and craftsmanship.

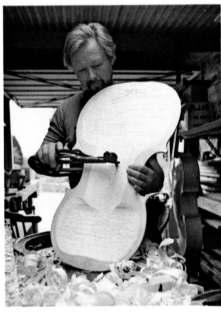

Three of the illustrations on these pages show Julian Emery shaping the front of a new Cello he is making. This involves constant measuring and 'sounding'. The tiny planes he uses are contrasted with the scroll work that has yet to be cut. In the last photograph the varnish on an instrument that is nearing completion is being examined.

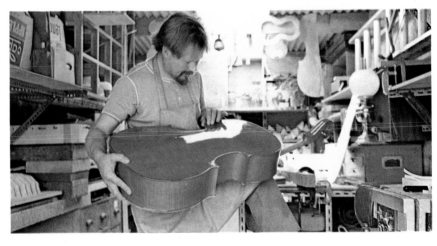

left
Once a first world war barrack hut, now a trug maker's workshop!

below right
Fitting together the framework of a trug basket in the steam room.

Sussex Trug Baskets.

In 1851, in the reign of Queen Victoria, Thomas Smith set out from the little village of Herstmonceux, in Sussex, with a selection of his garden baskets known by the peculiar name of 'Trugs'. He made his way to the Great Exhibition, in Hyde Park, and there set up his exhibits. The exhibition was, of course, the brainchild of Prince Albert so it was not surprising that the Queen should take a great interest in it. During one of her visits Her Majesty commended Thomas Smith's undoubtedly splendid craftsmanship and he was subsequently awarded a prize medal and a diploma. This was not all, however, for so taken was the Queen by Thomas Smith's trugs that she ordered some to be delivered to London to be used by the Royal gardeners. For Thomas Smith it had indeed been a successful exhibition. He returned to his workshop and immediately set

about making up the trugs that were destined to become the property of the Queen. The making of the trugs was no problem at all but when it came to considering how to deliver them, there was. Thomas Smith felt that he could not trust such an important consignment to the carriers of the day and he accordingly resolved to deliver them himself. He accomplished this by walking the sixty odd miles from Herstmonceux to London, carrying his trugs with him! If ever proof was needed of the pride of a craftsman in his product then surely this incident would serve admirably.

One of the trugs shown at that exhibition, together with the medal and the diploma, as well as other medals won at other, subsequent, exhibitions, may still be seen in the little office that forms the front entrance to Thomas Smith & Sons. These exhibits are shown to visitors with understandable pride and I

could not help thinking, as I held and admired the little trug basket, of the many people who must have held it in their hands and admired it in much the same way over the past hundred and twenty four years. It must be said, however, that the pride in these relics is fully equalled by the pride in craftsmanship with which the trugs that are still made in the little workshops today are constructed. I found it very refreshing, that in our plastics dominated age, there were collections of hand made trugs waiting to be shipped off to New Zealand, Australia, Canada and the United States, as well as to outlets all over the British Isles.

On seeing the various processes that are necessary to the making of trugs it quickly became obvious that this was not just a matter of 'knocking a basket together'. All the processes that go into their manufacture have been perfected through the years to ensure that only a product of the highest possible quality leaves the premises. The present owner of the business, Mr S. G. Sibley, has not found it necessary to alter any of the methods used, since it appears that there is virtually nothing that can be done that would materially improve the product or the way that it is manufactured. No doubt a machine made article could be produced that would resemble the present product, as

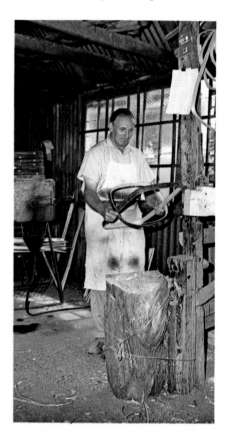

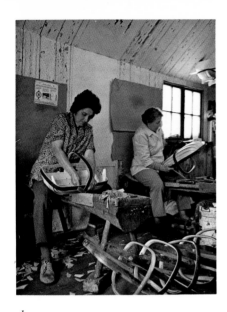

could (and has) a plastic version; but then they are not Sussex trugs and could never hope to compete with the real thing.

Walking into the main workshop, behind the office, it struck me that the building seemed vaguely familiar. It came as little surprise, therefore, to learn that it was originally an army barrack hut dating from the 1914-18 war! In a smaller room at the end of the hut, where now sit ladies engaged in finishing the trugs, once were stabled horses, and the main, long room once housed the soldiers. A grain store may still be seen, occupying the space above the office, where the feeding stuff for the horses was once kept.

Outside, at the rear of the building were piles of wood, mainly willow and sweet chestnut. Surrounded by the stacks of wood was Mr Lennard, a pensioner now, he couldn't stand being inside after a lifetime spent out of doors, and he still comes in, particularly on fine days, to cleave the long pieces of sweet chestnut into thinner lengths. It is essential to do this before the wood has dried out, otherwise the bark will peel away from the wood underneath. After seasoning these long strips of wood find their way into the main workshop where they are held on a wooden 'horse' astride which sits the trimmer. With a draw knife the strips of wood or 'straps' are trimmed with only the expert eye and experience of the trimmer himself for guidance. The bark is, of course, left intact as this will become the outer part of the

main frame. The next part of the process is for the straps and the willow boards (which will form the body of the trug) to be steamed. This particular task is carried out in yet another fascinating little annexe to the main building, where two steam ovens are installed. One of these is now heated by electricity but the other, its furnace fed from outside by waste wood, was constructed from an old ship's boiler! The steaming softens the wood to a quite remarkable degree, enabling it to be formed into the required shapes. In the case of the straps, these are bent round a 'former' of the required size, one for the rim and one for the handle. They are both roughly circular, with flattened sides. The 'formers' themselves are of wood, and in many cases are also well over a hundred years old – and in daily use! The rim is then fitted inside the handle, at right angles to it, the two parts being nailed firmly together to form the frame of the trug. During my visit this particular job was being carried out by Mr Honeysett who, without pausing in his work, told me of his father, who had been a wheelwright in the district. He told me that he had decided not to follow in his father's trade but had gone into agriculture, at which job he had remained for many years before eventually tiring of modern farming, and settling into his present craft.

While this was going on, Mr Honeysett's colleague was taking shaped planks of willow from the other steam oven and was gently bending them, in batches of five or

six at a time, between two securely fastened pieces of timber. Again, this was done by eye and experience alone and with quite remarkable accuracy and seeming ease. This is something that always strikes me about craftsmen; the ease with which they seem to do whatever they are engaged upon.

The frames and the beautifully prepared boards were now passed into the hands of the waiting ladies who would finally assemble them. Once more, this was done with no apparent urgency and yet with great speed and dexterity. The centre board was fitted, to be followed by the 'second' and then the 'side-boards', the ends were trimmed and, almost before you knew it, there was a completed trug, each one quite individually made and yet all apparently the same.

As is invariably the case where craftsmen and, I hasten to add, craftswomen are concerned, there was an air of happy informality about the whole workshop. A job was being done, and done well; a product was being turned out for which there was a great demand, and yet there was no suggestion of the air of anxiety that seems to attend those of us who find ourselves caught up in what we know as the 'rat-race'. Perhaps this is what keeps the craftsman at his craft and hopefully ensures that it will always be so.

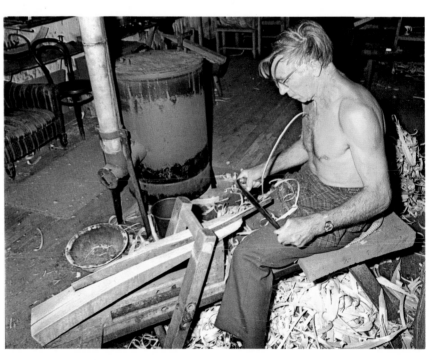

The Cricket Ball Maker.

There are many sounds that mean England to an Englishman. To some it will be the Church bells ringing out across the village green, to others it will no doubt be the sound of lawn mowers as front and back gardens are given their neat, once weekly trim, usually on Sunday mornings. Yet other people will immediately think of the solemn tones of Big Ben and the very English voice reading the day's news. There is no doubt at all, however, that there is one sound above all that epitomises England, particularly to a number of Englishmen, as opposed to Englishwomen, who live or spend a great deal of time abroad, and that is the sound that a cricket bat makes as it strikes a cricket

As with most other things, there is rather more to it than that!

Some time ago I was listening to two people discussing cricket in general and I particularly remember the price of good quality cricket balls being mentioned, and the remark being made that they were becoming far too expensive. I wish that both those people could have accompanied me on a visit to Teston, near Maidstone, in the Kent countryside perhaps more widely known for its orchards and its hop fields, where the premises of Alfred Reader and Company Limited are situated. I am sure they would have come away, as I did, wondering how such a beautifully fashioned article could be put together with such skill and sheer hard work and still only cost what it does!

The skill, of a remarkably high order, was in evidence at every stage of the manufacture of these entirely hand made products, as indeed was the hard work. The entire process is a lengthy one as well as being very in-

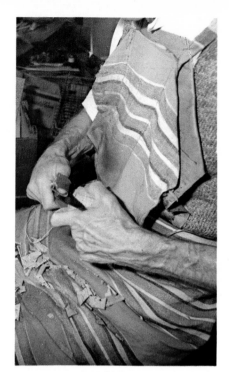

above
A 'Quilter' winding, with incredible accuracy the cork core of a cricket ball. On this craftsman's expertise depends so much of the work that is to follow.

below
Leather, which has been dyed for seven days, hanging to dry naturally in the area behind the main workshops.

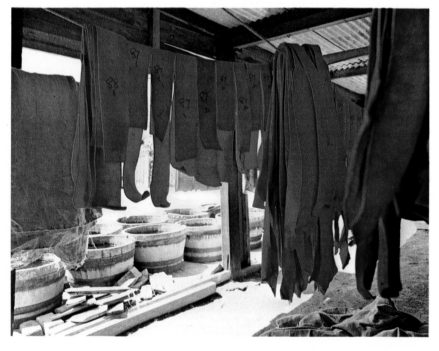

ball and speeds it, hopefully, on its way to the boundary.

To the cricketing fraternity, of course, a cricket ball is an extremely important item of equipment, but to the rest of us it is, I am sure, something that is either not thought about at all, or else is known to be simply a ball, leather covered and extremely hard.

volved. It would be impossible, as well as being insulting to the craftsmen concerned, to come away after one visit pretending to know all about this complex and exacting craft. I can only, therefore, write of things I saw that particularly impressed me and will remain in my mind for a long time. I recall first of all being shown

the stacks of hides, the best parts of which eventually find their way on to the outer part of the top quality balls, being cut into strips before being left in vats of red dye. The strips remain in the dye for seven days before being hung to dry naturally. When dry the strips of leather have to be stretched and kneaded to remove the stiffness brought on by the dyeing and drying process in addition to being 'planed' to a uniform thickness. 'Quarters', four of which will be used to make each cover, are cut out and carefully set aside, in sets, so that the same quality of leather, from the same skin, will form one cover.

While this is going on, the core of the ball is being produced in the 'quilting' room. Of all the processes I saw, this was the one that intrigued me most. Superbly hand made leather covers, individually stitched with all the care that expert craftsmanship is capable of is, at least, an understandable piece of workmanship. But to take a one and a half inch cube of cork and, by successively winding layers of wet worsted thread, (rather in the way a ball of wool may be wound but with the utmost precision), interspersed with more strips of cork, until a perfectly round, hard

ball is produced was something I found quite fascinating. True, at stages during the winding and layering the slowly forming ball is placed in a heavy metal cup in front of the operator and helped to its final shape by judicious hammering with a metal headed hammer, but this only made the whole operation more extraordinary. It must be remembered that a top quality cricket ball has to meet certain requirements as to both weight and size, and both these objectives were being made to coincide purely through the skill of the 'quilters'. One of these remarkable gentlemen, Percy, joined the company in 1919, after serving in the Great War, during which he was wounded. He does not work full time now as he will be celebrating his eightieth birthday before long, but he is still in great demand as an umpire at local cricket matches and, when he does go in to work, he can still turn that little cube of cork into the core of a first class cricket ball!

I must be careful lest I give the impression that there are only old, or at least long serving, craftsmen continuing these traditions, for this would be far from the truth. In the sewing room, for instance, where some of the most precise and exquisite work is carried out, young men are busily acquiring their skills under the watchful eye of Mr Page. There is so little that can successfully be mechanised in the making of their cricket balls that it is, quite naturally, of great concern to the company that there should always, if possible, be a new generation of craftsmen waiting to play their part.

Before the cricket balls themselves play their part, whether it be in a test match or a friendly on the village green, they have to be finished. This consists of yet another inspection before they have the brand name and other identification marks applied using gold leaf. Three coats of polish later and the ball is ready to be delivered–in both senses!

Prior to leaving, Mr Reader, who had been so generous in both the time he had given me and the expertise, handed me a leaflet about the products that bear his company's name. There is a footnote to the leaflet which I think it appropriate to quote:

'Since Alfred Reader and Company first started manufacturing cricket balls they have used enough thread to stretch approximately half way to the moon, 125,000

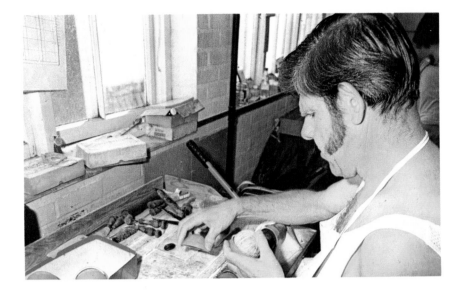

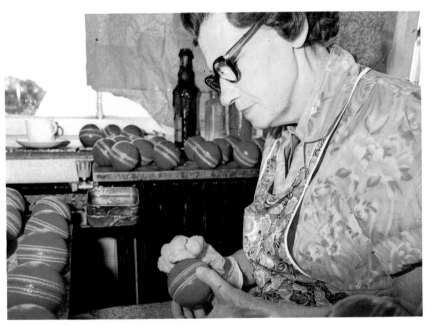

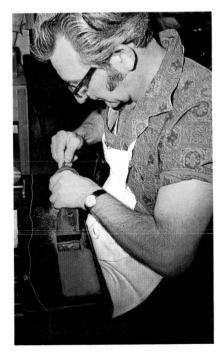

top
'Quarters' being fitted to the finished core of the cricket ball.

above
A final polish and the ball is ready for 'delivery'.

left
One of the many millions of stitches which, every year go into the making of this beautifully made product.

miles or 1,300 miles a year.

Since the war, Alfred Reader and Company have made 200 tons of cricket balls and the leather required to cover them would stretch for 23 acres, one million square feet.

In 12 months Reader operatives insert 7 million hand stitches and 5 million machine stitches in leather cricket balls.'

I think there is very little anyone can add to that!

Canterbury's Stained Glass.

Throughout these islands there are a great number of extremely beautiful cathedrals, and the enormous number of people who, almost every day of the year, visit them surely indicates their continuing popularity and the great interest and affection in which they are held. It seems fair to say that, of these cathedrals, probably none holds the imagination more than the magnificent example at Canterbury. Its associations with Thomas A' Becket, and with Chaucer's 'Canterbury Tales', and the fact that, despite its size, it still has a unique quality of intimacy as a place of worship, all contribute something to its special appeal.

As with all such buildings of great age, however, the problems of maintenance and restoration are quite enormous and work can never really be said to be finished. A constant battle against the ravages of time, weather, and the effects of pollution has to be waged, and a vital part of this battle is carried on under the direction of Mr Frederick Cole in the 'stained glass studio' adjacent to the cathedral. Here a team of craftsmen and craftswomen work constantly, and expertly, to repair and

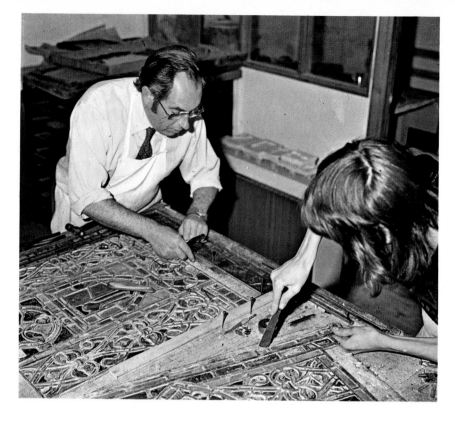

restore the cathedral's stained glass windows which, besides being virtually priceless, are such an integral part of its beauty.

Work of this nature obviously cannot be done in situ and so, when it becomes necessary, windows, or sections, are removed and taken down to the studio to be examined in order to determine exactly what action to take. At this stage photographs are taken and fully detailed records are made of every tiny detail of the window, to be filed away as

invaluable guides to future work.

Most of the windows are many hundreds of years old and 're-leading' has probably taken place many times over the preceding years. The work that is necessary can therefore vary quite considerably, from applying putty to the channelling in which the individual pieces of glass are seated, in a window that is otherwise quite firm and stable, to completely dismantling another into its small component pieces of glass, each of which has to be individually cleaned, with enormous care, before being reassembled in new lead channels and soldered.

If the condition of the window indicates that complete renovation is necessary then, in addition to photographing the window, a 'rubbing' is made on a large sheet of paper, rather in the way that brass rubbings are made, which will be essential as a guide to putting the cleaned glass together again. Once the rubbing has been made the lead which holds the pieces of glass can be removed, a small section at a time, with great care and delicacy. It would be all too easy to chip or break the fragile pieces of glass that have survived many centuries. It may well be found that some of these pieces are already broken, or have small cracks in them, besides being badly warped by the passage of time and the attentions of the atmosphere. In such a

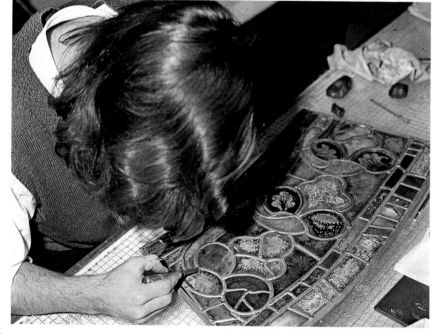

case it will most likely be necessary to cut a new piece of glass to exactly match the shape of the old and this will then be heated and moulded to exactly match the surface shape and contours of the damaged glass. The two pieces will then be mounted together in perfect contact when the window is reassembled, thus providing protection for the damaged glass. As I mentioned earlier, all the pieces of glass, once dissembled, have to be cleaned and this in itself is an extremely long and laborious process.

When the time comes to put the window together again a copy of the original rubbing, or maybe the original itself, is used as a base, so that each piece of glass may be returned to exactly the position it occupied before work began. Lead channelling is used which must be curved into the appropriate shapes, so that the individual pieces of glass fit firmly in place, one against the other. As the work progresses farrier's nails, the type used to shoe horses, are employed to secure each piece in place by being tapped into the bench on which the work is being carried out, against the edge of each piece of glass. Finally, solder is melted onto each of the joints so that the whole section becomes rigid and firm once more.

It will be obvious that the description I have attempted of the very complex work involved is no more than a brief outline of the method used. It can take months of exacting effort to restore just one panel, and the constant problems that arise all have to be solved before work can continue.

As with so many other crafts, there is a very real re-awakening of interest in the work of stained glass restoration and there is, consequently, a stream of visitors, photographers, television crews and so on calling at the studio and taking up very valuable time. It is to the great credit of the craftsmen involved that, despite this, they manage to continue with their work whilst answering the endless questions that are directed at them.

As to the quality of their workmanship, and the expertise with which the work is directed, it is only necessary to walk round the cathedral and enjoy the beauty of the many stained glass windows, to be afforded ample evidence of just how high this quality is.

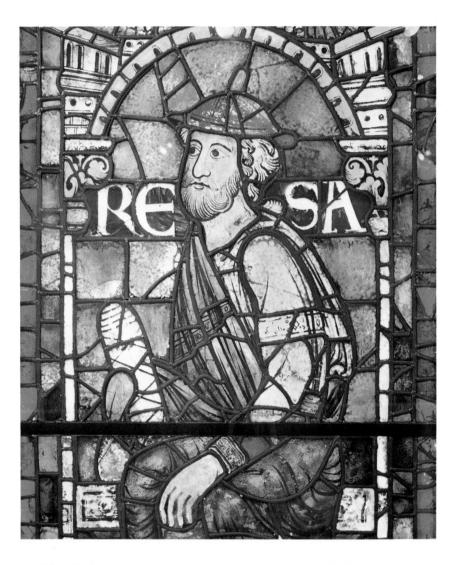

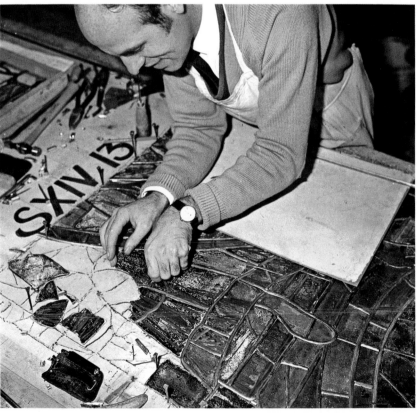

The Thatcher at Work

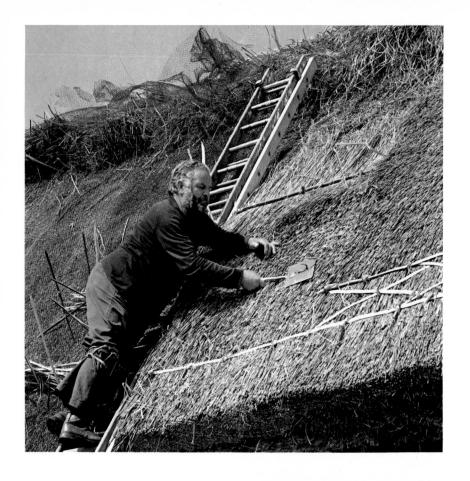

Almost everyone has day-dreams about the sort of life they would live, and the house they would live in, if they were completely free to choose, without any of the everyday considerations, like money, to take into account. However exotic or sophisticated such day-dreams may be, it would be no surprise to find that, in a large number of them an old-world thatched cottage figured quite prominently. It seems that there is something about a thatched roof that transforms, in many people's minds, a quite ordinary little cottage into someone's idea of a dream home. If there are roses rambling around the door, then so much the better!

Thatch – straw or reeds used as a roof over a dwelling – is one of the oldest methods of providing shelter against the elements and was commonplace in a great many areas until a comparatively short time ago. The raw materials, in one form or another, were readily available and therefore cheap to both lay and replace, and it was comparatively easy to lay, at least to the extent that it would provide adequate shelter.

With the passage of time a complete change around occurred. Where, once, expensive houses for the wealthy would be tiled in some way and the poorer people of the country areas would have to make do with thatch the reverse is now the case. Modern production methods have made tiling far more economical than thatching, particularly because of the enormous increases in labour costs and the special, and therefore expensive, skills required in the laying and maintenance of such a roof.

An additional problem has always been the high fire risk attached to thatched roofs. With modern methods of heating this is no longer quite so much of a hazard as it was in the days when open fires were universally used but, nevertheless it is considered, certainly by insurance companies, to be enough of an extra risk as to make premiums very much higher than for buildings with conventional roofs.

In terms of durability there is little doubt that Norfolk reed is the best proposition – and therefore, of course, also the most expensive – as it will

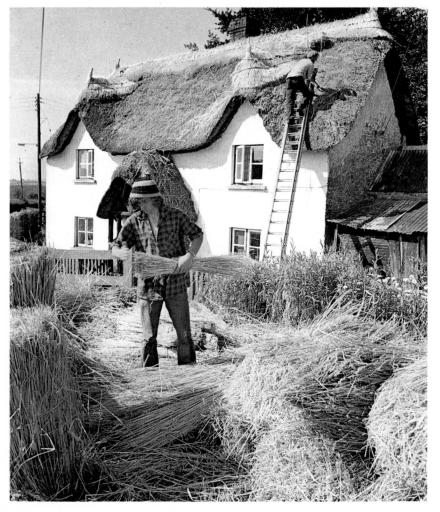

probably last at least twice as long as a roof thatched with wheat reed which, in turn, may last twice as long as ordinary long straw. Not surprisingly, Norfolk reed thatching is most common in East Anglia, whilst wheat reed predominates in the West Country.

It seems that, in nature, you cannot have things entirely the way you would ideally like them. For instance, modern varieties of wheat have been evolved to produce an increased yield of grain, but this has been achieved at the expense of the quality of the stalk, and it is the old type of stalk, without the high pith content, that is required for thatching. It is usually necessary, therefore, as in the making of corn dollies, to grow an amount of the older type of wheat for this very purpose. There is also the added difficulty that, in order not to damage the stalk of the wheat, older types of harvesting must be employed. All this adds considerably to the material costs involved in thatching, though it must in fairness be mentioned that the same problem, of quality, does not arise with Norfolk reeds. Providing that the reeds are harvested regularly they will grow straight and long, ideal for thatching.

With the exception of the growing acceptance of the lighter aluminium ladders, replacing the traditional long, single, wooden ones, the tools used in thatching have varied hardly at all over the years. It is a craft that would be virtually impossible to mechanise as each and every roof is so individual. Apart from the ladder, therefore, there is not a great deal that can be changed.

Whether Norfolk reed, wheat reed, or straw is being used the principle of laying the new thatch is very much the same. Work commences at the lower part of the roof with the cut ends of the reeds downwards and projecting to form an overhang. These lower reeds will eventually form the eaves of the new roof and it is essential that they clear the walls sufficiently to allow rainwater to be thrown clear. The reeds will also be thicker at the base than at the top and, when hazel rods are placed across the bundles of reed to secure them to the roof battens, this will have the effect of bending the ends slightly upwards so that, on the finished roof, only the ends of the reeds will be seen. Work continues up the roof with more bundles of reed being laid, and held in place by the rods, or 'sways' until the ridge is reached. As each successive layer is secured to the

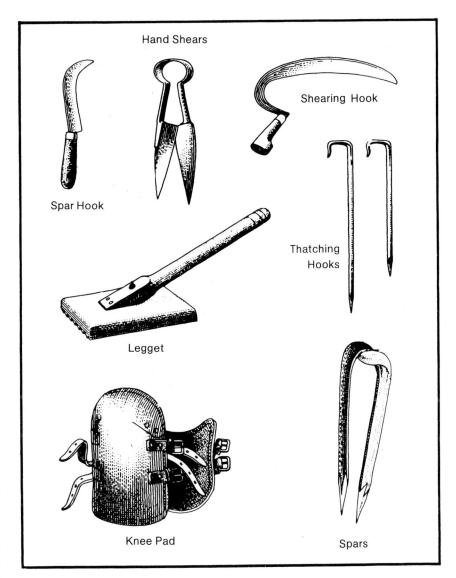

Hand Shears

Shearing Hook

Spar Hook

Thatching Hooks

Legget

Knee Pad

Spars

roof the 'legget', probably the most distinctive of the thatcher's tools, is used. This legget, as may be seen from the black and white illustration, is similar in appearance to the tool used by carpet layers to stretch carpets as they are laid. It consists of a flat piece of wood with a handle affixed at an acute angle. The face of the board has rows of projecting nails and this tool is used to literally beat the ends of the reed tight under the sways. The ridge of the roof always presents something of a problem as the reed cannot successfully be bent. This means that it has to be cut off at the ridge and, in order to weatherproof this vulnerable part of the roof, sedge, a type of coarse grass, is laid, extending some way down the slopes. This sedge is, in turn, covered by another layer of reeds, then another layer of sedge, the edges often being cut into attractive shapes. These shaped edges are frequently the trade mark of a particular thatcher and from them individual thatcher's work may be recognized.

All thatching is particularly vulnerable to rotting and attack by birds, although Norfolk reed is less likely to suffer from the latter than other materials. Part of the answer to the problem of water gathering, moss, and leaves, is to make sure that there are as few angles as possible where this can happen. It is for this reason that shallow sweeping curves are used, as for instance around dormer windows, and this not only provides the added protection needed but also, as a bonus, gives the thatched roof its characteristically gentle, undulating appearance which contributes so much to the charm of the finished work. Because of the high cost of thatching, and repairs, many roofs are nowadays covered with a fine mesh wire netting to help to prevent damage by birds.

Whatever the cost, difficulties with maintenance, high insurance rates and the like, thatched roofs are very much part of our rural heritage, and it would be a very sad day if they were no longer to be seen in our countryside.

INDEX OF CRAFTSMEN

AVON

Clevedon Craft Centre, Newhouse Farm, Moor Lane, Clevedon, Avon. BS21 6TD. Tel: Clevedon 872867.
At the Clevedon Craft Centre work by local craftsmen may be seen and bought in rural surroundings. Gold and silver jewellery and silverware. Tile and marble topped tables and trolleys. Illustrative and fine art photography. Custom-built kitchens and furniture. Landscape paintings. Pressed flower pictures.

Fishley Holland, The Pottery, Clevedon, Avon. BS21 6TE. Tel: Clevedon 872952.
Slipped earthenware vases, jugs, tankards, bowls etc.

Bertram Jelfs, Goose Grout, Wraxall Road, Warmley, Bristol, Avon. BS15 5DW. Tel: Bristol (0272) 673849.
Basketry of all types. Cane furniture a speciality. Chair caning, rush seating and scaining.

Cecilia R. Milton, Rock Cottage, Rock Road, Wick, Nr. Bristol, Avon. BS15 5TN. Tel: Abson (027-582) 2885.
Stoneware pottery without the use of the wheel or moulds with emphasis on texture and shapes. 'Old Jobber' figures, modelled working at various odd jobs, also other characters and animals. All pieces original.

Beach Pottery, 14 The Beach, Clevedon, Avon. Tel: Clevedon 5066.
Wide range of hand-thrown tableware and individual pots in stoneware.

BEDFORDSHIRE

Thomas Hudson, 35 High Street, Sharnbrook, Bedfordshire. MK44 1PF. Tel: Bedford 781423.
Thomas Hudson is a furniture maker and his work consists, mainly, of producing commissioned hand made pieces, incised lettering, church woodwork, wall panelling, and antique furniture restoration.

Mrs. P. M. Morgan, Mill Lane, Pavenham, Bedfordshire. MK43 7NL. Tel: Oakley (023-02) 2393.
Rush chair seats renewed. Rush table mats and baskets all made from self harvested rushes.

BERKSHIRE

Alan Caiger-Smith, Aldermaston Pottery, Aldermaston, Reading, Berkshire. RG7 4LW. Tel: Woolhampton 3359.
Most kinds of domestic pottery and ovenware – vases, jars, goblets, jugs, dishes, plates, punchbowls, tureens, tiles, etc. Private commissions; tiled tables, lamps, altar crosses and fonts, murals, and special domestic ware.

Anne Hoffman Soft Toys, Harwood House, Greenham Common South, Newbury, Berkshire. RG15 8HR. Tel: Headley, Newbury 275.
Operating on a Cottage Industry principle Anne Hoffman manufactures a wide range of hand-made soft toys and gift items of decorative value, from a small mouse to supersize standing elephants and bears. The range consists of some fifty items, all of which conform to established safety standards. Individual commissions are also accepted.

BUCKINGHAMSHIRE

Claycutters Studio, (Bill and Vicki Read), Sheep Street, (A413), Winslow, Buckingham, Buckinghamshire. MK18. Tel: Winslow 2663.
Reduction fired, high temperature stoneware. Half the production is of domestic ware and the remaining half consists of individual pieces.

Stuart King, Primrose Cottage, 17 Parish Piece, Holmer Green, High Wycombe, Buckinghamshire. Tel: Holmer Green 2027.
Maker of miniature antique chairs, accurate to the smallest detail, Stuart King is hoping to concentrate on making full size Windsor chairs to his own design in the near future. He also collects, and buys, all types of old woodworking tools.

Winifrede D. Morrison, Bolter End Cottage, Lane End, High Wycombe, Buckinghamshire. HP14 3LP. Tel: High Wycombe 881621.
Individually designed pressed flower pictures, framed in glass or sealed by a special process. Other items in this medium include table mats, bookmarks, cards, paper weights etc. Dried flowers, some dyed in subtle colours, are used for various arrangements, in small containers, on slate, in glass jars, and to decorate wooden spoons.

A. Rogers and Sons, Wood Turnery, 64 Higham Road, Chesham, Buckinghamshire. Tel: Chesham (02-405) 5276.
A family business engaged in wood turning, manufacturing a wide range of wooden table and kitchen ware including salad bowls, pepper mills, chopping bowls, fruit bowls, cheese boards etc.

Speen Weavers and Spinners, Speen, Aylesbury, Buckinghamshire. Tel: Hampden Row 303.
Hand woven fabrics, fine silks, silk base lampshades, dog-hair and wool cushions, sets of place mats, table linen, wall hangings, floor rugs.

Helen Whately (H. W. Pratt) 13 High Street, Marlow, Buckinghamshire. Tel: Marlow 3319/2763.
Dolls, in the form of period miniatures with features based on portraits of the time. The heads and limbs are either earthenware or porcelain and the figures are normally between 12 and 13 inches high. They are dressed in hand sewn clothes of silk, wool, linen or cotton, and the clothes also are based on those in contemporary portraits or on existing original costumes.

CAMBRIDGESHIRE

Robin and Mary Ellis, Rumwood, Horseheath, Cambridgeshire. CB1 6QX. Tel: Cambridge (0223) 891729.
Turners, designers and manufacturers. Fine pine tableware, selected by the Design Centre, sculpture-turned Objets d'Art. Will also undertake commissions, mainly for churches, for example, chalices and patens, gospel lights, candlesticks etc.

Den Young, 63 Earith Road, Willingham, Cambridgeshire. CB4 5LS. Tel: Willingham 60015.
Specialist doll house constructor, true scale, in any period from English Tudor to the present day. Fully detailed, they reflect a true picture of the original. Also any item of furniture in wood and metal to a scale of 1 inch to a foot.

CORNWALL

Roger Collicott Leathercrafts, 8 Harbour Craft Market,
The Wharf, St Ives, Cornwall.
Maker of high quality hand-made leathercraft. Range includes shoulder-bags, briefcases, belts, pots etc.

The Foster's Pottery Company, Tolgus Hill, Redruth, Cornwall.
Tel: Redruth 5754.
Makers of West Country Blue ware and novelty gift pottery.

Goodfellows Clocks, Penmellow Works, Trenant Industrial Estate, Wadebridge, Cornwall. PL27 6HB. Tel: 020-881 2115.
Longcase grandfather clocks, accurate reproductions, also grandmother and wall clocks. Goodfellows make the clocks complete, including the etched brass dial. The finish is hand French polished.

Paula Humphris Pottery, Rose Cottage, Mill Hill, Polperro, Cornwall. Tel: Polperro 439.
Earthenware slip-cast figures, animals, birds, fish, tiles, stoneware, hand built pots, pitchers, cider jars, lamp bases, punch bowls, plates, chess sets with mediaeval figures etc.

Lamb Swann Pottery, Adit House, Tresowes Hill, Ashton, Nr Helston, Cornwall. Tel: Germoe 2393.
A wide range of hand-made vessels in earthenware, stoneware and porcelain.

Leach Pottery, St Ives, Cornwall. Tel: 073 670 6398.
The Leach pottery produces a range of domestic ware, ovenproof stoneware and porcelain.

Liskeard Glass Limited, Station Road, Liskeard, Cornwall.
PL14 4PB. Tel: Liskeard 42399.
Liskeard Glass is a small firm which has only been established for 4 years. There are at present three skilled glass workers and a glass cutter, together with several young trainee glass-workers. The products, all entirely hand-made, include drinking glasses and tankards, candleholders, vases, paperweights and other ornamental glass.

Sancreed Studios, Sancreed, Penzance, Cornwall. TR20 8QS.
Tel: St Buryan (0736-72) 450.
Domestic stoneware produced in the pottery which was established by Michael Truscott in 1965. Also high quality picture framing, picture restoration and cleaning.

Sloop Craft Market (John Buchanan), St Ives, Cornwall.
Tel: St Ives 6051.
John Buchanan is a potter running a small workshop at the Sloop Craft Market. He produces a range of tableware fired in an oxidizing atmosphere. His main interest is in creating individual works which vary widely in their mood and are made with a variety of clays and glazes.

Tremar Potteries Limited, Trecarne, Liskeard, Cornwall.
PL14 5EF. Tel: Liskeard 42771.
Complete range of oven-to-table stoneware and giftware. Craftsman-made, no two pieces are alike, and all are designed and produced within the county of Cornwall.

Wendron Forge Limited, Wendron, Helston, Cornwall.
Tel: Helston (03265) 3531.
The craftsmen at Wendron work as a team in the following way: The designers and artists in the studios prepare drawings from which the other craftsmen make up the end products. These other craftsmen consist of hand-printers and etchers working on metal, picture frame makers, carpenters and joiners and assembly ladies. Working closely together, the team produces a range of metal pictures, clocks and furniture which is exported widely.

CUMBRIA

Barkers of Lanercost, Holmefoot, Lanercost, Brampton, Cumbria. Tel: Brampton 2638.
High quality hand made goods by local craftsmen. Silverware, jewellery, prints, hookie rugs, Cumbrian bonnets, collage and embroidered pictures. Speciality is a range of 18th, 19th and 20th century dolls and exclusive soft toys. Individual commissions undertaken for dolls, toys, rugs and sculpture.

Gail Fisher, Skiddaw Pottery, Rear Lake Road, Keswick, Cumbria. CA12 5DQ.
Traditionally thrown stoneware and local mixed clay pottery, on sale in various shops in the Lake District and also exported to Sweden. The work includes domestic ware, boxes, candle lanterns and planters. All the glazes used are mixed from raw materials in the workshop.

G. Michael Gibbon, Barn Gallery and Workshop, Parkside House, Cartmel, Grange-over-Sands, Cumbria.
Tel: Cartmel 392.
Master woodcarver and fine art wood sculptor. Designer cabinet maker. Own permanent exhibition of life figure sculptures and other works in his Gallery, a stone and slate 17th century Lofted Long Barn.

F. B. Mercer, Hand Loom Weaver, Eastern Cottage, The Park, Hallbankgate, Brampton, Cumbria. CA8 2PF.
Tel: Hallbankgate 309.
Hand woven woollen tweeds of various weights suitable for such purposes as ladies' skirts, coats and costumes. All processes from weaving to the final finishing of the cloth are carried out by hand in the traditional cottage method so that no piece is ever exactly repeated.

DERBYSHIRE

Bolehill Quarries Limited, Wingerworth, Chesterfield, Derbyshire. Tel: Chesterfield 70244.
In addition to supplying hundreds of other craftsmen with stone and slate the Bolehill Quarries employ highly skilled masons producing craftsman made decorative walls and fireplaces as well as hand worked cills, mullions, enrichments, plaques and carvings etc., as used on prestige buildings.

DEVON

E. C. Blake, Higher Cleave, Wilmington, Nr Honiton, Devon.
EX14 9SG.
Hand-made Shepherd's crooks, Trigger grip and Cleave grip, Thumb sticks, walking sticks and riding canes. All made from locally grown wood; hazel, holly, ash, blackthorn and finished with six coats of varnish.

Clive Bowen, Shebbear Pottery, Shebbear, Beaworthy, Devon.
EX21 5QZ. Tel: Shebbear 271.
Ovenware, tableware, crocks and storage jars, hand-thrown from a local red earthenware clay and fired with wood.

Michael Emmett, White Cross, Offwell, Honiton, Devon.
Tel: Wilmington 483.
Hand-thrown domestic stoneware, also from time to time, a range of terracotta crocks.

Jean L. Flynn, Ashburner Cottage, 3 Station Road, Topsham, Exeter, Devon. EX3 0DT. Tel: Topsham 4536.
Spinning, dyeing and weaving. Wall hangings, wall decorations, floor rugs.

Gawlish Cottage Crafts, Hartland, Devon.
Machine stitched patchwork, bedspreads, cushions, aprons, jerkins, caps, pin cushions and wall hangings by Rita Burn. Steve Howlett makes small wooden hand-made items such as letter racks and book racks and also bookshelves and occasional tables, etc. Both open to special orders in the respective crafts.

Eric Golding, Branscombe Pottery, Higher House, Branscombe, Seaton, Devon. EX12 3BH.
A wide variety of hand-thrown, reduction-fired stoneware, also decorative items such as bowls, vases, lamp bases etc., which are decorated with slip, using a variety of techniques.

Michael Hatfield, Seckington Pottery Models, Winkleigh, Devon. EX19 8EY. Tel: Winkleigh (083-783) 478.
Ceramic models, mainly of animals and birds, the most popular of which are grey or white mice. In addition Devon cider mugs, vases, pendants, wall-plaques etc.

Lionel Heath, Old Forge Pottery, 39 Ringmore Road, Shaldon, Devon. Tel: Shaldon 2415.
Domestic pottery in stoneware. Coffee sets, wine sets, teapots, punch sets and some individual pieces.

Judith E. Hughes, Norstead, Downs Road, Tavistock, Devon. PO19 9AG.
Fine hand-made furniture and woodwork designed and made for individual clients in a variety of woods. Specialist in inlaying, marquetry and monograms.

Bernard Jones, Beaford Pottery, Old Parsonage, Beaford, Nr Winkleigh, Devon. EX19 8AQ. Tel: Beaford 306.
A wide range of domestic stoneware pottery, all wheel thrown using a locally produced clay, consisting of mugs, jugs, coffee sets, teapots, plates, dishes, casseroles, goblets, etc.

Donald Mattock, White House, Luton Cross, Ideford, Newton Abbot, Devon. TQ13 0BQ.
Since 1969 has been working with transparent Perspex and nylon line to produce sculptural pendant and table lamps. His work has been widely shown, including the Royal Academy, The Royal West of England Academy, The Royal Glasgow Institute of Fine Arts and the Society of Designer-Craftsmen.

W. H. Moulsley, Petrockstow Forge, Petrockstow, Okehampton, Devon. EX20 3HW.
Ornamental wrought iron work, general smith.

Alan Peters, Aller Studios, Kentisbeare, Cullompton, Devon. Tel: Kentisbeare 251.
Furniture designer and maker. Commissions accepted for single pieces of furniture or for complete room schemes.

Dave Regester, Bickleigh Mill Craft Centre, Bickleigh, Tiverton, Devon.
Wood turner and carver. Specialises in such items as traditional cheese boards, breadboards, wooden platters, bowls of all sizes and candleholders. Carved house signs, decorative work, and some restoration of old carvings.

James Robertson, Bickleigh Mill Craft Centre, Bickleigh, Nr Tiverton, Devon. EX16 8RG. Tel: Bickleigh 413.
Professional lapidary. Manufacturer of natural stone jewellery and supplier of a very comprehensive range of materials and equipment for lapidary and jewellery making.

S. Sanders and Son Limited, Pilton Bridge, Barnstaple, Devon. Tel: Barnstaple 2335.
Fellmongers. Makers of sheepskin coats, rugs, gloves, slippers, and a range of toys. Also woollen scarves, headsquares and ties.

Spindles Studio, Ringmore, Shaldon, Devon. TQ14 0HJ. Tel: Shaldon 2437.
Phyl Shillinglaw and Lucile Clarkson produce hand-woven materials, Batik, and tie-dyed articles with emphasis on plant dyes and the use of various woods as dye-stuff. They also produce a small amount of press-moulded dishes, hand-built pots and models.

Robert Stubbings of Modbury, Overmeadows, Modbury, Devon. Tel: Modbury 493.
Quality pine furniture designed and hand-made. A complete range including bedroom, living room, kitchen etc., furniture. Scandinavian and Russian timber of the highest quality. Individual commissions undertaken.

DORSET

The Country Workshop of Wood Art, Ron Draper, Manor Farm, Walditch, Bridport, Dorset. Tel: Bridport 3403.
The company specialises in building hand made model horse drawn vehicles to the original designs of the many different counties. Original, full size waggons also restored when the opportunity presents itself.

Guild Crafts, Fontmell Magna, Shaftesbury, Dorset. SP7 0PA. Tel: Fontmell Magna 597.
Potters and woodworkers.

Adrian Lewis-Evans, Stoney Down Pottery, Lytchett Matravers, Dorset. Tel: Lytchett Minster (020-122) 2392.
Stoneware and porcelain. Ash glazed vases, pitchers, tankards, Dorset 'Owl' cider flagons etc.

Anna Milner Pottery, Old Down House, Horton, Wimbourne, Dorset. BH21 7HL. Tel: Witchampton 373.
Currently producing a large range of domestic stoneware; mugs, jugs, carafe sets, dinner sets. Oven-to-table ware; pie dishes, souffle dishes, au gratin dishes etc. Also a number of individual vases, candleholders and chess sets.

S. Moores, Morcombelake, Bridport, Dorset. DT9 6ES. Tel: Chideok 253.
Makers of speciality Dorset biscuits and shortbread.

The Owl Pottery, Leslie Gibbons, A.T.D., 108 High Street, Swanage, Dorset.
The Owl Pottery concentrates on highly decorated hand made earthenware. They produce thrown and moulded pieces and specialise in individual dishes with pictorial motifs and bold graphic designs in majolica and slip. These include owls particularly, but also other birds and animals, and intricate incised designs in a primitive style. The pottery also has available ceramic jewellery, hand decorated tiles, and a selection of drawings, paintings, prints and small sculptures.

Pilgrims Craftsmen (Shillingstone) Limited, Old England Yard, Shillingstone, Blandford, Dorset. DT11 0SA. Tel: Child Okeford (025 886) 673.
Fine hand made furniture specially made to customers individual requirements. Each piece made from solid dried timber, signed by the craftsman whose work it is.

Diana Snook, 'Just-U', Corn Croft, Church Lane, Lower Blandford St Mary, Blandford Forum, Dorset. Tel: Child Okeford 433.
Soft toys, including dressed rag dolls, fur fabric monkeys, hobby horses and a selection of mules and other animals. Hand finished children's clothes.

M. K. Wood, Matravers Farm, Uploders, Bridport, Dorset. Tel: Powerstock 300.
Hand printing and firing onto domestic enamelware.

ESSEX

William Catley, The Old Bakery, Wicken Bonhunt, Nr Saffron Walden, Essex. Tel: Saffron Walden 40575.
Makers of fine period furniture, antique restorers and French polishers. A full range of Queen Anne walnut chests, lowboys, tables, chairs and sideboards are made by skilled craftsmen, in addition to Sheraton style mahogany dining room suites. Individual pieces are also made to order.

Stephanie Kalan, London Road, Newport, Saffron Walden, Essex. CB11 3PN. Tel: Saffron Walden (0799) 40358.
Ceramics. Specializes in glazes for which extensive research has been carried out. A crystalline glaze has been developed, of which the Victoria and Albert Museum have two examples.

GLOUCESTERSHIRE

Campden Pottery, Muriel Tudor Jones and Jean Bright, Leasebourne, Chipping Campden, Gloucestershire.
Tel: Evesham 840315.
Hand-thrown earthenware made on the premises. One or two local shops supplied, but the majority of the work is sold in the shop adjoining the pottery.

L. K. Clatworthy, Theocsbury Mayde, Barton Street, Tewkesbury, Gloucestershire.
Woodcarving specialist in the traditional style, working mainly in elm, but also in sycamore and pear. Also armour, swords and daggers, forged and beaten out in the traditional way.

Richard Dewar, Pottery Workshop, Yew Tree Cottage, St Briavels, Gloucestershire. Tel: St Briavels 297.
Functional pottery for use in the home, ranging from oven-to-table ware and general kitchen ware to more individual items such as wine and cider sets, various assortments of teapots, and large house and garden pots. Large pots are also produced including pancheons, large 'charges' and bread crocks.

Forest of Dean Pottery, Peter Saysell, Bream, Lydney, Gloucestershire. GL15 6JS Tel: Whitecroft 562414
Contemporary paintings and ceramics. All types of thrown and built pottery, stoneware and earthenware, reflecting the beauty of the forest and of the Wye valley area. The most important work to date is a large ceramic mural on the gable end of Gloucestershire's Shire Hall. Original range of platters in natural shapes.

R. H. Fyson, Manor Farm, Kencot, Lechlade, Gloucestershire. GL7 3QT. Tel: Filkins 223.
Cabinet maker. Furniture for church, college and domestic use. Architectural joinery, carving and antique restoration, with particular emphasis on the special skills of gilding, painting, carving and brass inlaying which have been developed to meet the needs of this type of work.

H. A. Hargreaves, Stones, Bagendon, Cirencester, Gloucestershire. GL7 7DU Tel: North Cerney (028-583) 370
Large unglazed earthenware pots, 12-18 inches high, for terraces and for house plants.

Peter Hill, Antiquarian Horologist, The Old Toll House, Littleworth, Sedgeberrow Road, Winchcombe, Gloucestershire. GL54 5BT Tel: Winchcombe 602151
Restoration of old and antique clocks and watches of various types; long case clocks, bracket, lantern, wall, carriage etc. Pocket watches of the verge, duplex, cylinder, repeater types. Also hand built clocks of a regulator type to specification.

A. V. Nicholls, The Old Smithy, Lower Swell, Stow-on-the-Wold, Gloucestershire. GL54 1LF
Tel: Stow-on-the-Wold (0451) 30041
Traditional wrought ironwork. Light fittings and lanterns in iron, brass and bronze. Adam grates and dog-baskets. Cast iron fire-backs. Restoration work. Ecclesiastical metalwork. Pinchbeck platters. Water clocks and mechanical clocks. Weather-vanes and wind-dials.

Geoff Payne, The Back Lane, Fairford, Gloucestershire. GL7 4AJ Tel: Thames Way 352
Rushweaver. Rush and cane seating repairs and restoration.

Saydisc Specialised Recordings Limited, The Barton, Inglestone Common, Badminton, Gloucestershire. GL9 1BX
Tel: Wickwar 266
Publishers of historic and specialist records ranging from local dialects to street organ music and including several on country life and crafts, Cotswold stone walling, hurdle making, the Wheelwright etc.

Sheep Street Studio, Sheep Street, Stow-on-the-Wold, Gloucestershire. Tel: Stow-on-the-Wold 30120
Judy Law's work at present consists mainly of porcelain and terracotta jewellery, with glaze on glaze decoration.

The Snake Pottery, Peter C. Brown, Green Street Cottage, Cam Green, Dursley, Gloucestershire. GL11 5HW
Tel: Dursley 3260
Small, but full time, one man rural pottery. Products include figure mugs and jugs, puzzle jugs, frog mugs, fuddling cups, tygs, slipware platters and beer mugs of every kind including a special limited edition commemorating each general election. Individual named or inscribed pots can be commissioned. Heraldic decoration is a speciality.

Dennis Trinder, The Old Bull Inn, Filkins, Nr Lechlade, Gloucestershire.
Makers of all kinds of ironwork, gates, railings, firebaskets, fireside sets, fore screens, light brackets, weather vanes etc., all made in the traditional way.

Weatherall Workshops, Weatherall, Perrygrove, Coleford, Gloucestershire. GL16 8QB. Tel: Colesford (05943) 2102.
Designers and producers of prize winning needlepoint and applique wall hangings, bedspreads, cushion covers etc. The workshops are under the direction of American artist and designer Lillian Delevoryas.

Winchcombe Pottery Limited, Winchcombe, Gloucestershire. GL54 5NU Tel: 0242 602462
A wide range of domestic stoneware for oven, kitchen, and table use. As well as the standard range, which is repeatable, a small number of individual pieces are made.

HAMPSHIRE

Harington Carpets Limited, Froxfield Green, Petersfield, Hampshire. GU32 1DQ. Tel: Petersfield 3998.
Designers and manufacturers of hand tufted carpets, rugs and wallhangings, to any design, size, colour or shape. Pile heights range from 5mm loop to 50mm loop or cut, and many of the goods are produced in varied pile heights. All the products are made from 100% pure new wool.

Old Forge Pottery, 37 Durrants Road, Rowlands Castle, Hampshire. PO9 6BE. Tel: Rowlands Castle 2632.
Specialists in the production of hand thrown and hand moulded stoneware pottery. Although a large part of the time is taken up with the production of dinner services, coffee sets, wine carafes and goblets, they have branched out into all forms of carved and painted decorative ware and sculptural work.

HERTFORDSHIRE

Kimpton Flowers, The Commons, Kimpton, Hitchin, Hertfordshire. SG4 8HA. Tel: Kimpton (0438) 832389.
Original designs of pictures with flowers by Mary Lees, using real flowers and grasses on pure silk backgrounds.

St Crispin's Glass (A. E. Charles), 28 St Albans Road, Codicote, Nr Hitchin, Hertfordshire. SG4 8UT.
Stained glass mosaic windows and panels which are made of a combination of painted design and stained glass tesserae of varying shapes, sizes and thicknesses.

Clare Street, Little Offley Farm, Hitchin, Hertfordshire. SG5 3BU.
Tel: Offley (046-276) 202.
Gold and silver jewellery, including wedding and engagement rings. Hand engraving, including seal engraving and miniature portraits on copper, silver or gold executed from clients' photographs. Some redesigning of customers gemstones also undertaken.

G. D. H. Willson, M.I.E., M.I.S.M., T.Eng. (CEI),
Format Design Associates, 40 Grace Gardens, Bishop's Stortford, Hertfordshire. CM23 3EX.
Decoratively carved and modelled murals derived from brass rubbings and photographs. Knights and their Ladies, ancient coins, studies of wild life – Owls, Kingfishers, Squirrels etc., presented in hand made frames with coloured hessian backgrounds, or free hanging unframed. Also a novelty range of small animals in wood-like finishes.

HEREFORDSHIRE

Bernard Ellis, Musical Instrument Maker, The Coach House, Dilwyn, Herefordshire. Tel: Weobley 583.
Early music and traditional stringed instruments. Appalachian Dulcimers, Autoharps, Square Fiddles, Mediaeval 5 stringed Fiddles, Hammer Dulcimers, Rebecs, Hurdy Gurdy etc. Constant research on old instruments is made through books and museums to provide information on instruments to be made in the future.

J. Arthur Wells and Company Ltd., Gatsford, Ross-on-Wye, Herefordshire. HR9 7QL. Tel: Ross-on-Wye 2595.
Craftsmen in wood. All types of wooden furniture to commission. High class joinery to commission, especially in connection with period building restoration and reconditioning and repair of antique furniture. Design and construction of timber staircases of classical and unique contemporary style.

HUMBERSIDE

Wold Pottery (Routh) Limited, Routh, Beverley, Nth Humberside. HU17 9SR. Tel: 0401 42236.
Wold pottery is known for the quality of its rich warm glazes, and its leaf dishes – where a real leaf is impressed into the clay. The range also includes coffee sets, wine sets, bowls, tankards, vases, beakers – anything that can be thrown on a potter's wheel.

SOUTH HUMBERSIDE

A. N. Watson, White Cottage Pottery and Gallery, King Street, East Halton, Grimsby, South Humberside. DN40 3PY.
Tel: Killingholme 308.
Craft potter at present producing mainly stoneware, both oxidized and reduced. The range includes functional ware such as tableware, goblets, flagons, large storage jars, bottles, casseroles etc. In addition, large decorative tiles and some ceramic sculpture using slip-cast in conjunction with thrown techniques.

NORTH HUMBERSIDE

Margaret E. Wolverson, A.T.D., Wychelm, Atwick Road, Hornsea, Nth Humberside. HU18 1EG. Tel: Hornsea 3356.
Mainly commissioned works. Original miniature oil paintings of hunting and other equestrian scenes, horse or horse and rider portraits. These are small oval paintings 2 to 2 1/2 inches across but a locket painting can be as small as 1/2 inch across. Also entirely hand made Collector's costume dolls individually designed and made to represent either particular historical characters, or be typical of a certain age in fashion.

KENT

Barbara M. Bowden, Leybourne Mill, 13 Castle Way, Leybourne, Kent. ME19 5HF.
Tel: West Malling (0732) 842577.
Stained glass artist, Church or domestic windows executed or repaired.

Broadstairs Pottery Co. Limited, Dundonald Road, Broadstairs, Kent. Tel: Thanet 62548.
Producers of a full range of domestic tableware in oxidized stoneware. A large range of lamp bases is also made.

The Harris Centre, Highgate House, Hawkhurst, Kent.
TN18 4AP. Tel: 058 3315.
The Harris Centre has been established for the encouragement of design and craftsmanship in weaving, spinning, and for instruction in other craft skills. An information service on the crafts is available, and the work of designer-craftsmen in weaving and in many other fields may be commissioned through the centre. Courses and private tuition in weaving and spinning are held, together with lectures on craft subjects.

Hyders Limited, Plaxtol, Nr Sevenoaks, Kent. TN15 0QR.
Tel: 073-276 215.
Art metal workers. Specialists in hand-forged wrought ironwork. Balustrades, gates, railings, electrical fittings, wellheads, firemesh curtains, weather vanes, signs, fireplace accessories, grilles, garden furniture, jardinieres.

R. F. Knight, Panfield Cottage, Burlings Lane, Knockholt, Kent.
Tel: Knockholt 2068.
Individually designed hand-forged wrought ironwork; fire baskets etc.

LANCASHIRE

Ron Carter, Trapp Forge, Simonstone, Burnley, Lancashire.
Tel: Padiham 71025.
Hand-forged ironwork – dog-grates, fire-irons, gates, railing, staircases, grilles, lanterns, brackets, porch grilles etc.

Robin and Nell Dale, Bank House Farm, Holme Mills, Holme, via Carnforth, Lancashire.
Tel: Burton (in Kendal) (0524) 781646.
Designers and makers of dolls and toys, their speciality being the English wooden doll, turned and hand finished in their own workshop. In addition to their own wide range of dolls they will also make others to customer's requirements.

Margaret Jones, Hazeldene, West End, Great Eccleston, Preston, Lancashire. PR3 0YL. Tel: Great Eccleston 70319.
Hand made pewter and ceramic jewellery, in which pottery stones are set in hand beaten pewter to produce rings, pendants, brooches, earrings, cuff links etc. Margaret Jones also makes candles embossed with real flowers and leaves.

Kneen Thornton Pottery, Potters Barn, 2 Fleetwood Road North, Thornton Cleveleys, Blackpool, Lancashire. Tel: Cleveleys 5045.
Large range of hand-made pottery in porcelain, stoneware, and high-fired earthenware. Domestic and decorative items. Ceramic jewellery, murals to order. Candles hand-made on the premises.

LINCOLNSHIRE

Edmund Czajkowski and Son, 96 Tor O' Moor Road, Woodhall Spa, Lincolnshire. LN10 6SB.
Tel: Woodhall Spa 52895.
Cabinet makers, furniture designers and antique restorers. A father and son team who will make, to a very high standard, any kind of furniture to clients' individual requirements. Michael Czajkowski, the son, restores antique clock movements and cases, and also makes cases for clocks when required.

Anthony Edmonds, Tydd Pottery, Tydd Road, West Pinchbeck, Spalding, Lincolnshire.
Domestic earthenware. Red clay with transparent glaze. Plant and garden terracotta pots. The domestic range includes mugs, various sizes of jugs, eggcups, candle holders, casseroles, cheese dishes, plates and bowls. Commemorative plaques are also produced.

Studio Workshop, Glebe Cottage, Normanby-le-Wold, Caistor, Lincolnshire. LN7 6SU. Tel: Owesby Moor 383.
Paintings, prints and ceramics. Limited editions of prints, usually 15-30 prints to a colour edition and larger editions of 50-100 for black and white work. Glazed earthenware pottery is also produced in the workshop. Open to the public at weekends, at limited periods during the year, otherwise by appointment.

MIDDLESEX

M. D. Gratch, Gera and Associates, 17 Bruce Road,
Harrow and Wealdstone, Middlesex.
Tel: (01) 427 1831 (evenings)
Furnishing accessories – wood turner. Complete dinner sets, dinner plates, salad bowls, fruit bowls etc. Custom built kitchens to order, made of solid timber to customers choice. Re-rushing and re-caning chairs, and repairs to chair frames.

NORFOLK

Balmas Limited, Tudor Barn, The Street, Old Costessey,
Near Norwich, Norfolk. NOR 51X. Tel: Norwich 742811.
Repairers of musical instruments. The workshops, under the direction of A. F. Masters and G. Balding, are situated in a Tudor thatched barn. Repairs are carried out to violins, cellos, harps, pianos, harpsichords and all types of stringed instruments, French horns and all brass instruments, clarinets, flutes etc.

The Country and Cottage Crafts Project, Wroxham Road,
Coltishall, Norfolk. NR12 7DW. Tel: 549 (060-543).
H. J. Horne M.B.I.M., Project Director. A non profit making concern founded with the object of promoting and fostering the work and interests of talented local craftsmen and women. The individually hand-made products of over fifty outstanding craftsmen and women can be examined, bought, or commissioned. The products range from furniture to corn dollies, and include soft toys, pottery, basketry, brass rubbings, wrought iron, rushwork, leatherwork, flower pictures, hornwork, tumblestone jewellery, chess sets, wood carving, patchwork, enamelled copper, house nameboards, beadwork, macrame, glass engraving, and much more.

Edgefield Pottery (Dawn and Terry Hulbert), Old Hall Cottage,
Rectory Lane, Edgefield, Melton Constable. NR24 2RJ.
Tel: Saxthorpe (026-387) 379.
Stoneware pottery made on the premises. Hand thrown tableware, individual hand built pots, individual dinner services to clients' requirements and sculptures of a distinctive nature.

Alan Frewin, Millhouse Pottery, Harleston, Norfolk. IP20 9ES.
Tel: Harleston (0379) 852556.
Mainly domestic once fired slipware. Pie dishes, cider jars, salt kilns etc., decorated with corn, reeds, flowers and birds.

North Heigham Sawmills, Paddock Street, off Heigham Street,
Norwich, Norfolk. NOR 52K. Tel: Norwich 22978.
Suppliers to a large number of instrument makers and craftsmen with a variety of specialist and exotic woods.

Michael A. Kearns, The Old Forge, Roughton, Norwich,
Norfolk. NR11 8AF.
Primarily concerned in embedding natural objects such as flowers, grasses, shells, etc., in polyester and acrylic resins to produce paperweights, doorknobs, finger plates, pen-holders and decorative panels for doors, windows and tabletops. For commercial requirements, various other items, nuts and bolts, business cards, sporting and military insignia are embedded to form paperweights, penholders and trophies. All work is individually produced.

Saint Furniture, Two Saints Farm, Tunstead Road, Hoveton,
Norwich. NR12 8QT. Tel: Wroxham 2732.
Craftsman made reproduction and modern furniture, and repairs and restorations. A line of very high quality furniture is now being produced, based on the Sheraton period, with a considerable amount of inlay work – crossbanding etc. The furniture consists of card, tea, side, and sofa tables; bow-fronted chests, and other small pieces. Commissioned work is also undertaken.

Sheringham Pottery, Church Street, Sheringham, Norfolk.
Tel: Sheringham 3552.
Jetty Farncombe and her husband, Adrian, produce glazed earthenware, all of which is hand built, without the use of conventional equipment or machinery. The pottery is made by slab, coil, pinch pot, and composite methods, ensuring that each piece is unique, a quality enhanced by the glazing techniques used. A wide range of table and functional earthenware is made, including coffee and tea sets, table lamps, jugs, flower holders etc. Much of the work embraces tree, leaf and flower motifs and forms.

Richard Spendiff, Croft Barn, Edingthorpe, North Walsham,
Norfolk. Tel: North Walsham 2291.
High quality chairs, particularly the 'Shaperite' designed for the elderly and convalescents, and dining suites, usually in mahogany and oak.

John and Kate Turner, The Pottery, Narborough, Norfolk.
Tel: Kings Lynn 208
Hand made domestic stoneware and individual pieces.

Whittington Pottery, Whittington Stoke Ferry, Norfolk.
PE33 9TG. Tel: Stoke Ferry 491.
West Marshall is a potter producing, in the main, thrown domestic ware such as coffee sets, tea pots, mugs, bowls, casseroles etc. All the handles and lugs are extruded and are usually decorated with a roulette.

Corbett Woodwork, Corpusty, Norwich, Norfolk. NR11 6PQ.
Tel: Saxthorpe 268.
Producers of solid wood furniture in English hardwoods.

NORTHAMPTONSHIRE

Blakesley Pottery Studio, David Crick, 9 High Street, Blakesley,
Towcester, Northamptonshire. NN12 8RE.
Tel: Blakesley (032-732) 461 (evenings)
Domestic oxidized hand-thrown stoneware designed and hand made in studio which is next to old converted coaching inn. Flower vases, flower pot holders, general purpose bowls, mugs, plates and occasional pieces of artware.

Duncan James, 49 Banbury Road, Brackley, Northamptonshire.
NN13 6BA. Tel: Brackley (028-03) 2948.
Duncan James is a designer-craftsman producing jewellery in gold and silver by both fabrication and casting techniques. A standard range of items is made in limited quantity to supply gallery outlets, supplemented by unique designs and work carried out to commission. Casting of limited editions of small sculptures in bronze, silver and gold undertaken for established artists.

E. F. Joyce and Co., 4 Lumbertubs Lane, Boothville,
Northampton. NN3 1AH.
Tel: Northampton (891123) 43936.
Craftsmen in stone. Restoration of stonework to churches and historic buildings. New stonework to buildings. Fireplaces to clients' designs, mostly built in situ. Garden ornaments, monumental letter cutting, memorials.

NOTTINGHAM

Hamlyn Lodge Cottage Industry, T. S. Barrows and Son,
Welbeck, Worksop, Nottingham. S80 3LR.
Tel: Worksop (0909) 85252.
Rex and Norman Barrows, cabinet makers, make furniture to
customers' own particular requirements. When available choice
antiques, pottery and paintings, can be seen and purchased.
Monthly exhibitions of work by artists and craftsmen, one month
being devoted to each individual. Residential weekend courses,
and one day courses, in antique furniture restoration are
available.

C. and M. Hemstock–Ceramics, Old Great North Road,
Sutton-on-Trent, Newark, Nottingham. NG23 6PL.
Tel: Sutton-on-Trent 282.
Traditional English red earthenware pottery, about 40% of which
is exported to the USA and Canada. Most of the pottery is
hand thrown and includes plant pots of all sizes, bulb bowls,
bread crocks, bread pancheons, bread bakers, milk coolers,
chicken bricks, parsley growers, seed trays and strawberry
growers.

Marcus Designs, Normanton Lane, Bottesford,
Nottingham. NG13 0DA. Tel: Bottesford (0949) 42519.
Mediaeval reliefs and ornaments hand made and reproduced
from sculpture created by D. H. Morton, authentically based
on the period represented. A specially developed process imparts
a richly coloured metallised finish. Each item is accompanied
by a parchment-type card giving, in old English script, historical
information.

OXFORDSHIRE

Michael and Heather Ackland, Coniston House, New Street,
Deddington, Oxfordshire. OX5 4SP.
Tel: Deddington (086 93) 241.

Designers and makers of modern silver and gold jewellery, much
of the work incorporates gem stones such as amethyst, carnelian,
moss agate and moonstone. As well as employing the traditional
methods of forging and fabrication the 'lost wax' technique is
also used in casting precious metals. The products are being
extended to other silver work in addition to jewellery – small
bowls, boxes, spoons etc.

Aston Woodware, Aston Hill, Lewknor, Oxfordshire.
Tel: Kingston Blount 51500.
Solid English timber furniture, mainly in Oak, Elm and Yew.
Refectory tables, dressers, benches, coffee tables, stools, and
garden furniture are all sold direct to the public from the above
address and also from a 15th century barn showroom in Kingston
Blount.

Crowdys Wood Products Limited, The Old Bakery, Clanfield,
Oxfordshire. OX8 2SP. Tel: Clanfield 216.
Cabinet Makers and Woodturners specialising in dining room
furniture and one-off pieces to customers' requirements. Oc-
casional and garden furniture, lamps, tableware, toys, spinning
wheels. All original designs and all made on the premises.

Culworth Forge, Culworth, Banbury, Oxfordshire.
Tel: Sulgrave 439.
Agricultural engineering, welding, Blacksmithing and Farriery.
Most forms of metalwork undertaken. Of particular interest is
the decorative wrought iron work that the company produces.

Geoffrey Harding, 31 The Green, Steventon, Abingdon,
Oxfordshire. OX13 6RR. Tel: Steventon (023-584) 371.
Silversmith. Hand-wrought silver sugar casters, wine cups,
tankards, spoons, coffee sets, candlesticks, communion cups etc.

Mrs P. McClean, 24 Haydon Road, Didcot,
Oxfordshire. OX11 7JD.
Mrs McClean designs and paints scenes and floral arrangements
on fine canvas for working in petit point. Most of this work is
done to order and is used for re-upholstering old chairs and
stools.

Vardoc Fabrics Limited, Church Lane, Old Marston,
Oxfordshire. Tel: Oxford 42515.
Woven wool ties and headsquares etc. The company use all
pure new wool and weave their own cloth, from yarn dyed to
their own specifications, to make their products.

SOMERSET

Jaquie Baker MSDC., Weavers Dream, Barton St David,
Somerton, Somerset. Tel: Baltonsborough 584.
Corn dollies, both modern and traditional, about fifty different
designs. Jaquie Baker keeps her own Jacob sheep for their fleeces
and, using as many dyes from the hedgerows as possible, produces
exclusive, handspun and handwoven clothing – jackets, skirts,
shawls etc.

Keith and Maggie Barnes, Barton House, Ashill, Ilminster,
Somerset. Tel: Hatch Beauchamp 469.
Design Council approved toys including the 'Convertible' baby
walker, pullabout wagon and many others. All the toys are
hand-built at Barton House.

Mrs Oenone Cave, Rambler Studio, Holford, Somerset.
Tel: Holford 315.
Interior decor and embroidery specialist. Exclusive lampshades
made to individual design. Complete lamps – craftsman made
bases in stoneware, glazed earthenware, Somerset woods,
wrought iron and glass. Embroidery books and materials
supplied.

Martin J. Dodge, Southgate, Wincanton, Somerset. BA9 9EB.
Tel: Wincanton 2388.
Makers of fine English furniture from solid Honduras mahogany,
polished by hand to a wax finish.

Dove Centre, Crispin Hall, High Street, Street, Somerset.
Tel: Street (9924) 5172.
A resident community of professional artists and craftsmen
making high quality products and teaching students. Amongst
the products made by the group are: pottery, tableware, oven-
ware, jewellery, etched glassware, weaving, enamelwork, furni-
ture, prints, paintings and drawings.

Exmoor Sheepskin Shop Ltd., 40 The Avenue, Minehead,
Somerset. TA24 5AZ. Tel: Minehead 2917.
Specialist manufacturers and retailers of sheepskin, leather and
suede coats, gloves, handbags, rugs, slippers etc.

C. C. and A. E. C. Fisher, The Taunton Pottery, 87 Outer Circle,
Taunton, Somerset. TA1 2BT.
Tel: Taunton (0823) 82605 evenings, 74505 daytime.
Fine hand made pottery including a wide range of tableware,
mugs, bowls, casseroles and large studio pieces. Also a range
of character animals and figures, some dressed in aprons, smocks,
hats, bonnets, shawls–each one an individual.

Glastonbury Prints, 5A High Street, Glastonbury,
Somerset. BA9 9DP. Tel: 0458 32420.
John Morland's original fine line drawings of birds and flowers
are printed and then each one is hand coloured by artists who
work in their own homes, after undergoing a short but rigorous
training programme. All the frames and mounts are made in
their own workshops and the assembly is strictly controlled to
ensure that each picture is of the highest quality.

McCoy Saddlery and Leathercraft, High Street, Porlock, Minehead, Somerset. TA24 8QD. Tel: Porlock 518.
A complete range of saddlery and equestrian goods is produced, also a range of hand tooled leatherwork including belts and handbags, all leather wastepaper bins and bellows. Saddlery and general leathergoods repairs also carried out.

Milverton Craft Workshop (Beth Designs), Fore Street, Milverton, Nr Taunton, Somerset. Tel: Milverton 528.
Fine Somerset crafts. Corn dollies, pottery, basketware, woodware, weaving, toys, ties, tweeds, jewellery etc.

Somerset House Wedmore Limited, Station Road, Cheddar, Somerset. BS27 3AE. Tel: Cheddar (0934) 742210.
Somerset House Wedmore was set up to help keep alive the craft of corn dolly making and also to help to give employment to people unable to go out to work for any reason. A wide range of corn dollies and corn dolly kits, complete with full instructions, are available.

John Wood and Son (Exmoor) Ltd., Linton, Old Cleeve, Minehead, Somerset. TA24 6HT. Tel: Washford (098-44) 291.
Wool sheepskin dressers using mainly English sheepskins and manufacturing hand sewn sheepskin moccasins in two styles; the Exmoor Moccasin and the Brendon Moccasin. Also sheepskin floor rugs both in natural colours and dyed.

SUFFOLK

The Bulmer Brick and Tile Co. Limited, Bulmer, Nr Sudbury, Suffolk. Tel: Twinstead 232.
Manufacturers of hand-made, sand-faced, multi-red facing bricks; purpose-made special bricks, and moulded and carved terracotta. Bulmer bricks have been used for all types of building and are particularly suitable for period restoration work.

Doreen Sanders, Pippin Cottage, Woodditton, Nr Newmarket, Suffolk. CB8 9SQ.
Natural hand-woven rugs, wall-hangings, cushions, curtaining, mats etc. Some stock lines and also private orders and commissions undertaken.

Henry Watson's Potteries Limited, Wattisfield, Suffolk. IP22 1NH. Tel: Walsham-le-Willows (035-98) 239.
A wide range of domestic oven-to-tableware studio pottery in a kitchen brown glaze.

Felix White, Glass Engraver, The Flints, Conyers Green Farm, Great Barton, Bury St Edmunds, Suffolk. Tel: Great Barton 675.
Diamond Point Glass Engraver. Commissions accepted for commemorative occasions, retirements, weddings, and for the reproduction of houses, coats of arms, themes connected with places of interest, any subject suitable for the medium. Designs selected for the Design Centre.

SURREY

Wharf Pottery, 55 St Johns Street, Farncombe, Godalming, Surrey. GU7 3EH. Tel: Godalming 4097.
Mary Wondrausch is a Folk potter working in the 17th century manner. She specialises in making commemorative ware in earthenware to celebrate weddings, christenings, birthdays, gold, silver or ruby anniversaries etc.

Richard Quinnell Limited, Rowhurst Forge, Oxshott Road, Leatherhead, Surrey. KT22 0EN. Tel: Leatherhead 75148.
Master craftsmen in iron, particularly hand forged wrought ironwork of every type and for all purposes. Also gilding, woodcarving, lettering and signs, sculpture, sandblasting, shotblasting, polishing and lacquering, marble and stone, heraldic and architectural reliefs in metallic fibreglass, and work in bronze, brass, aluminium and stainless steel.

SUSSEX

Aruncraft, Riffards, Burpham, Arundel, Sussex. BN18 9RJ. Tel: Arundel 883143.
M. G. Hay-Will specialises in the restoration of antique furniture and, occasionally, makes matching copies. A one-time venture, never likely to be repeated, is the recent limited edition of fifty copies of antique pieces of furniture in miniature, made out of 4,000 years old yew wood disinterred from the Arun valley.

Margaret F. Bellamy, Thorn House, The Street, Chiddingly, Sussex. Tel: Chiddingly 466.
Wood Carver, Sculptor and Turner now specializing in carved work and wood turned between centres, rather than end turning. Decorative fruits, as made in the eighteenth century, such as pears, apples and figs, made in a variety of woods. Dishes for decorative fruits, turned and carved small sculptures of birds and fish etc., book ends, altar crosses and candle holders.

Derek Davis, Duff Gallery, Tarrant Street, Arundel, Sussex. Tel: Arundel 882600.
Porcelain and stoneware pottery using decorative glazes.

Rustic Crafts Limited, Bixley Lane, Beckley, Rye, East Sussex.
Craftsmen in rustic and roundwood joinery. A range of outdoor furniture, structures and requisites for gardens and parks etc., includes gates and fencing, arches and pergolas, sign frames, chairs, seats, benches and tables.

Martin Stanesby M.S.D.C., Little River Farm, River, Nr Petworth, Sussex. GU28 9AS. Tel: Lodsworth 312.
Designer and maker of hand made furniture, mostly commissioned work in oak and other hardwoods to designs drawn up in consultation with the client. Varied work including refectory tables, dining chairs, Welsh dressers, panelled blanket chests and settles, coffee tables etc.

WARWICKSHIRE

Wood and Paper, Norman and Joan Hunt, 2, Oberon Close, Bilton, Rugby, Warwickshire. Tel: Rugby 811232.
Hand screen printing. Framed prints in limited editions.
Screened wooden toys; Hobby horses, traction engines, dolls' cradles, coat pegs, push-along toys. Also Greeting cards, children's stationery, tray jigsawss

WILTSHIRE

Hector Cole, The Mead, Great Somerford, Chippenham, Wiltshire. Tel: Seagry 485.
Traditional hand-forged domestic wrought iron work. Fire baskets, companion sets, pokers, toasting forks, chestnut roasters, fire dogs etc. Also gates, lamps, flower stands, candle holders, table and swords.

Jean Davies Crafts Limited, Burnbake, Wilton, Salisbury, Wiltshire. SP2 0ES. Tel: Wilton (0772-74) 2553.
Producers of hand-made costume jewellery from such materials as horse shoe nails, metal washers, copper, wire, chain, sequins, buttons and wooden beads. The range includes pendants, bracelets, ear clips, chokers and rings. All the products are marketed nationally.

Berowald Innes, Pinknew Pound, Nr Sherston, Malmesbury, Wiltshire SN16 0NZ. Tel: Sherston (066-649) 373.
Hand-weaver, specializing in rugs and wall-hangings to customers requirements.
Embroiderer, specializing in heraldic work, wool on canvas or needlepoint, in a wide variety of stitches. Work suitable for firescreens, stools, chairs etc. Coats of arms, family and regimental crests, heraldic beasts and other devices.

John Collett, Townsend Farm, Littleton Drew, Chippenham,
Wiltshire. SN14 7NA.
Traditional craft potter making a variety of country wares; jugs,
cooking ware, cheese dishes, salt kits etc.

M. and P. Mullen, Bridgefoot, Mantles Lane, Heytesbury,
Warminster, Wiltshire.
Traditional rush seating and chair caning for the antique trade
and for private customers.

Rodney P. Naylor MSD-C, Turnpike House,
208 Devizes Road, Hilperton, Trowbridge,
Wiltshire BA14 7QP. Tel: Trowbridge (02214) 4497.
Woodcarving and sculpture in a variety of styles. Bronze and
silver casts. Trophies, chess sets, murals and mirror frames etc.,
made to the clients specification, or are available from stock.

A. G. Phillips, Brokerswood House, Brokerswood,
Near Westbury, Wiltshire. Tel: Westbury (82) 2238.
A commercial forestry concern engaged in the production, for
retail sale, of bean sticks, pea sticks, thatching spars, thumb
sticks, walking sticks, nameplates, garden furniture, bird tables
etc.
The White Horse Spinners and Weavers,
(Mr and Mrs C. G. Charles), Beech Bank, Bratton,
Westbury, Wiltshire. BA13 4TE. Tel: Bratton (038-083) 382.
Hand spun knitting wool and knitted garments. Tweeds, floor
rugs, shawls, stoles, shoulder-bags and small travelling rugs.
Tie-dyed pure silk scarves and head squares.

WORCESTERSHIRE

Birlingham Ironwork, Dairy Cottage, Eckington Road,
Birlingham, Pershore, Worcestershire. Tel: Eckington 284.
Wrought Iron work, hand forging and light fabrication and
welding. Mr J. A. Jacks will tackle any job that requires iron
such as ornamental ironwork, gates, screens and iron utensils,
garden tools, wheelwrighting etc. He also demonstrates, to school
parties, firewelding and the general manipulation of iron.

YORKSHIRE

Acorn Industries, G. J. Grainger and Son, Brandsby,
Yorkshire. YO6 4RG. Tel: Brandsby 217.
Craftsman made furniture in all woods. Inlaying and carving to
customer's individual requirements.

Kathy Cartledge, Oysterber Ceramics, Oysterber Farm,
Low Bentham, Lancaster, Nth Yorkshire. LA 2 7ET.
Tel: Bentham (0468) 61567.
Stoneware for domestic use, lamp bases and murals.

Albert Jeffray, Sessay, Thirsk, Yorkshire. YO7 3BE.
Tel: Hutton Sessay (084-53) 323.
Woodcarver and cabinet maker. Hand-carved furniture and gifts
for church, domestic and office use. English oak dining and
occasional furniture a speciality.

Kilvington Studio, South Kilvington, Thirsk,
Yorkshire YO7 2LZ. Tel: Thirsk (0845) 22328.
Hand-made furniture to individual requirements, in any style,
and in any type of wood, in addition to veneering, wood-turning,
hardwood toys, laminated work, metal framed furniture
incorporating ceramic tops etc.

Ernest Stanley, Brompton Mill, Brompton-on-Swale, Richmond,
Yorkshire. Tel: Old Catterick 476.
Ernest Stanley is a furniture craftsman with nearly fifty years
experience in hand and machine made woodwork. His main
products are copies of 18th century pieces, and traditional and
modern furniture in all timbers and veneers.

Nidderdale Design Workshop, Bridgehousegate,
Pately Bridge, Nr Harrogate, Yorkshire. Tel: Pately Bridge 294.
Hand-thrown domestic pottery and free form sculpture.

Sedburgh Pottery, Millthrop, Sedburgh, Yorkshire.
Stoneware goblets, mugs, jugs, vinegar jugs, lamp bases, coffee
sets, salt jars, vases, carafes and storage jars, all decorated, various
glazes. Also very large pieces to order.

Robert Thompson's Craftsmen Limited, Kilburn, Nr York,
Yorkshire. Tel: Coxwold 218.
A large range of fine domestic furniture in English Oak, all with
the distinctive 'mouse' trademark. Also fitted furniture,
Ecclesiastical, library and school.

Treske Limited, Station Works, Thirsk,
North Yorkshire YO7 4NY. Tel: (0845) 22770.
English furniture made from wood grown in Yorkshire hand
assembled and hand finished to a very high standard. Chairs,
benches, stools, tables in a variety of shapes and styles, Welsh
dressers, kitchen utensils, games, shelves etc.

Robin Watson, Robin's Return, Hunton, Bedale,
Yorkshire DL8 1QU. Tel: Constable Burton 388.
Woodcarvers specializing in the carving of unique coffee tables
depicting hunting scenes, ploughing horses etc., and carved house
signs as well as carved plaques of wild animals, horses and dogs.

WALES

CLWYD

Isla Gladstone, North Park, Hawarden, Deeside,
Clwyd CH5 3NY. Tel: Hawarden (0244) 531954.
A small exclusive firm specializing in hand screen-printing of
textiles to order. Designs for specific customers as well as samples
and screens of about sixty designs which can be printed to the
required colours on the textiles chosen. In the main the printed
samples are for furnishing fabrics, but also for dress materials,
household requisites and wallpaper.

DYFED

John Baum, The Pottery, Ridgeway, Narbeth, Dyfed.
Tel: Llawhaden 268.
A large range of wheel and hand-thrown stoneware pottery and
macramé. The standard line includes animals, wind bells, hanging
planters, wall plaques, bread crocks, lamp bases, macramé
lampshades and individual pieces.

Joe Cardiff, Tycanol, Crymych, Dyfed.
Authentic reproduction spinning wheels of traditional design.

Holywell Textile Mills Limited, Holywell, Clwyd CH8 7NU.
Tel: Holywell 2022/3/4.
Manufacturers of all wool blankets and travel rugs, tapestries,
Welsh flannels and Welsh tweeds.

Cambrian Woodcrafts (Flint), 23 Ffordd Llewelyn, Flint,
Clwyd CH6 5JY.
Welsh love spoons carved, as far as possible, in the 17th century
manner from single blocks of elm from Llangollen, the home
of the International musical Eisteddfod.

Caeglas Gemcraft, Pen-uwch, Tregaron, Dyfed SY25 6QZ.
Tel: Llangeitho 674.
Violet Pruden makes fashion jewellery in semi-precious stones,
mostly individual designs.

Inskin, (E. D. and T. B. Morris), West Street, Fishguard, Dyfed.
Tel: Fishguard 2510.
Suede and leather clothing, hats, handbags, belts etc., made to
order.

L. R. Davies, Old Fire Station, Tregaron, Dyfed.
Tel: Tregaron 410.
Jewellery and items in gold and silver from the simplest of small silver rings to candle snuffers, model horse-drawn ploughs, Celtic torques etc. Gold work includes wedding and engagement rings, antique look gold necklaces etc.

John Morgan and Son, Rock Mills, Capel Dewi, Llandysul, Dyfed SA44 4PH. Tel: Llandysul (055-932) 2356.
Manufacturers of pure new wool balankets, tapestry bedspreads, tapestry cloth, table mats, cushion covers, tea cosies, socks, stockings etc. The mill is operated by a water wheel–one of the few left.

Saundersfoot Pottery, Wogan Terrace, Saundersfoot, Dyfed.
Tel: Saundersfoot (81) 2406.
Hand thrown earthenware by Carol Brinton. A wide range with distinctive designs and glazes. In addition, the pottery produces a number of limited edition and individual pieces.

Simon Rich, The Narberth Pottery, 2 Market Street, Narberth, Dyfed.
Simon Rich works with stoneware clay specializing in finely thrown kitchenware and goblets. All pots are fired in an oxidized atmosphere at 1280°C. Painting, with a Japanese brush, slips coloured by oxides onto a Cornish stone based glaze produces unique decoration in shades ranging from brown to blue.

B. and C. Smazlen, Llanlleban, Hermon, Glogue, Dyfed.
Tel: Crymmych (023-973) 280.
Love, cawl and decorative spoons. Also one eighth scale models of waggons, carts, horses and ponies, and other farmyard equipment.

Wolfscastle Pottery, (Maddy and Philip Cunningham), 'Lordship', Wolfscastle, Dyfed.
Small family Pottery. Reduced stoneware, complete range of domestic pots, vases, bread crocks, garden terrace pots, bird baths and wash hand basins.

GLAMORGANSHIRE

Ammonite Limited, Llandow Industrial Estate, Cowbridge, Glamorgan CF7 7PB. Tel: Cowbridge (04463) 2029.
Designers and manufacturers of gold, silver, and gold plated jewellery in Celtic and modern styles, including silver and gold love spoons and charms.

GWENT

Barrie Naylor, Malthouse Pottery, Brockweir, Chepstow, Gwent. NP6 7NG.
Stoneware pottery, table ware, kitchen ware and decorative pieces. Some abstract sculpture.

GWYNEDD

Brynkir Woolen Mill Limited, Golan, Garndolbenmaen, Gwynedd. LL51 9YU. Tel: Garndolbenmaen (076-675) 236.
Manufacturers of Welsh tapestry, flannel, tweed, honeycomb and tapestry bedspreads.

Conwy Pottery, 8 Castle Street, Conwy, Gwynedd.
Tel: Conwy 3487.
Pottery workshop producing a range of hand-thrown stoneware pottery with oatmeal matt glaze and blue or horsechestnut decoration.

Charles Jones, Glengarry, Criccieth, Gwynedd. LL52 0DG.
Tel: 076-671 2833.
Hand carved Welsh love spoons. Hand carved Welsh spinning and prayer stools. Miniature Welsh dressers.

Llanfair Ym Muallt Pottery, Penrhyn Castle, Bangor, Gwynedd.
Hand-made studio pottery, including chess sets.

The Mineral Kingdom, Tyrpeg Bach, Nantmor, Gwynedd.
Tel: Beddgelert 286.
Hand-made jewellery incorporating mineral specimens, cut stones, tumbled stones etc.

Trefriw Woollen Mills Limited, Trefriw, Gwynedd.
Tel: Llanrwst 640462.
Products manufactured from the fleece to the finished article include tapestry and honeycomb bedspreads, tapestry cloth, tweeds, travelling rugs, cellular wraps and knitting wools.

POWYS

Cambrian Factory Limited, Llanwrtyd Wells, Powys. LD5 4SD.
Tel: Llanwrtyd Wells (05913) 211.
Wool sorting, dyeing, blending, carding, spinning, warping, winding and weaving to produce single width quality Welsh tweeds, all by disabled people.

P. J. and B. Flint, The Lodge, Norton, Presteigne, Powys.
Tel: Presteigne 361.
Antique furniture and horse-drawn vehicles restored. Reproduction antique stone and lead garden ornaments manufactured.

Sycamores Leather, (Ray Nicklin and Pam Evans), Sycamores Cottage, Quabbs, Beguildy, Knighton, Powys.
Tel: Beguildy 667.
Hand-made, individually designed leather goods made from best quality British cow hide.

Wye Pottery, (Adam Dworski), Clyro, via Hereford, Powys. HR3 5LB. Tel: Hay-on-Wye 510.
Earthenware and stoneware pottery. Figures, sculpture and plaques.

INDEX OF CRAFTSHOPS

AVON

Celtic Crafts Limited, Templar House, Temple Way, Bristol. BS1 6HD. Tel: Bristol 298375/6.
Welsh tapestry garments, handbags and bedspreads, also sheep-skin rugs, moccasins, pottery, toys, Aran knitwear, Welsh slate etc. Branches at: Bath, Cirencester, Llangollen, Ruthin, Nannerch, Minehead, Cwmduad, St. Ives, Polperro, Pentewan, Carmarthen, Newport and Capel Curig.

Coexistence Limited, 10 Argyle Street, Bath, Avon BA2 4BQ.
Tel: 0225 61507.
A wide range of furniture, lighting fabrics, wallpaper, paints, bathroom fittings, tiles, carpeting, furnishing accessories, paintings and prints. Also specialist books on architecture, art and design. Coexistence are also design consultants and hold regular exhibitions of work by both internationally and lesser known artists.

Rainbow over Clifton Limited, 9-10, Waterloo Street, Clifton, Bristol. BS8 4BT. Tel: (0272) 311543.
Clothes for adults and children, including quilted and smocked work; knitwear, most made locally; jewellery, silver inset with resin, enamel and semi-precious stones; pottery from several different sources; toys, including locally made soft toys, rag dolls, kites etc; cards, limited range of hand-painted and etched cards.

BEDFORDSHIRE

Arts and Crafts, 18 Slicketts Lane, Edlesborough,
Dunstable. LU6 2JD. Tel: Eaton Bray 220255.
Pottery by Brendan Maund, candles, pendants, woodware,
basketwork, tatting, crochet, pillow-lace, needlework, shell
designs, soft toys, ties, jewellery, bird boxes, honey, copper,
wrought-iron, artificial flowers, silverware, painting etc.

Woodland Craft Centre, Thurleigh Road, Milton Ernest,
Bedford. Tel: Oakley 2914.
Pottery, toys, hobby horses, wooden goods, mobiles, crochet work,
rushwork, corn dollies, dried flower arrangements, embroidery,
puppets etc., etc.

Serendib, (Colin and Marianne Mulrenan), 15, Market Place,
Woburn, Bedfordshire. Tel: Woburn 464.
Handcrafts and works of art. Paintings, collages, pottery,
ceramics, jewellery, glass, woodcrafts, light furniture, pewter
and metalwork, rushware, soft toys, greetings cards etc.

BERKSHIRE

The Bothy at Rectory House, Warfield, Berkshire.
Tel: Winkfield Row 2324.
Pottery, jewellery, wood carvings, enamelwork, West Indian
tortoise shell, Cyprus embroidery, patchwork etc.

CHESHIRE

Cheshire Crafts, 8 Chorley Hall Lane, Alderley Edge.
Original pottery and paintings. Also jewellery, hand-loom
weaving, leatherwork, candles, copper enamelled ware, horse
shoe nail jewellery, collage, canework, woodwork, dried flower
arrangements and pictures, pressed flower pictures and a variety
of soft toys.

CORNWALL

The Craftsmens Centre, The Quay, Polperro. PL13 2QU.
Tel: Polperro (050-38) 398.
Studio pottery, ceramics, steel and copper etchings, sheepskin
footwear, tweeds, rugs, ties, woodturning and carving etc.

Faculae Design, 7 Passage Street, Fowey.
Tel: Fowey (072-683) 2345.
Cornish delabole slate, jewellery, paintings, pottery, lettering, etc.

Fogou Crafts, Withy Cottage, Porthallow, St. Keverne,
Helston. TR12 6PL. Tel: St. Keverne 567.
Knitwear, studio pottery, crocket work, doll's clothes, basketry,
soft toys, large model ships, small camphor propelled model
ships. Several items made on the premises.

Sloop Craft Market, St Ives. Tel: St Ives (073-670) 6051.
Pottery by John Buchanan, also hand-blown glassware, leather-
work, wood carving etc.

DERBYSHIRE

Sudbury Hall, Sudbury. DE6 5HT.
Tel: Sudbury (028-378) 305.
National Trust souvenir shop selling pottery, paintings, turned
and carved wooden objects, and corn dollies.

Yew Tree Cottage Gallery, Ingleby, Stanton by Bridge.
Tel: Melbourne (07993) 2894.
Although always open by appointment, the gallery does not
operate as a craft 'shop' as such. Instead, three exhibitions are
held very year, each lasting a month, and featuring the work of
various craftsmen and artists.

Handmade, The Cross, Calver, Derbyshire.
Tel: Grindleford 30019.
Probably the smallest craft shop in Britain. Studio pottery,
jewellery, toys, woodwork, pomanders, leatherwork etc.

DEVON

City of London Hide and Skin Company Limited,
(Associate Company—Strong, Rawle and Strong Limited),
Willand, Cullompton, Devon.
Tel: Sampford Peverell (0884) 820 567.
Sheepskin products, including life-like animal studies, hand-
made in real fur.

Lotus Gallery, Stoke Gabriel, Totnes, S. Devon.
Tel: Stoke Gabriel (080-428) 303.
Various craft products on sale.

S. Sanders and Son Limited, Pilton Bridge, Barnstaple, Devon.
Tel: Barnstaple (0271) 2335.
Various sheepskin goods and toys.

The Shop on the Green, Widecombe-in-the-Moor,
Newton Abbot, S. Devon. Tel: Widecombe 218.
Specialists in quality craftware produced in the West Country.
Hand-made pottery, glass, woodware, corn dollies, watercolours,
maps, prints. Dartington Hall tweeds and mohair, Dart knitwear,
hand-woven ties, sheepskin gloves and various assorted giftware.

DORSET

Gallery 24, 24 Bimport, Shaftesbury, Dorset.
Tel: Shaftesbury (0747) 2931.
A gallery exhibiting the work of both new and internationally
known artists. A very wide range of ceramic and domestic
pottery by leading craftsmen always on show in addition to a
range of jewellery.

HAMPSHIRE

Hiscock Gallery, 11 Stanley Street, Southsea, Hants. PO5 2DR.
Tel: Portsmouth (0705) 25330.
Various potters work on show throughout the year. Wire
sculpture by Elizabeth Gallop. Some weaving, jewellery and
mosaics. Glass engraving by John Hutton.

HEREFORD AND WORCESTER

Ceejay Craftwork, 5 High Street, Ross-on-Wye,
Hereford and Worcester. Tel: Ross-on-Wye (0989) 3000.
English, Welsh, Scottish and Irish craftwork. Pottery, tapestry,
garments, materials, glassware, paperweights, leather bags,
purses, wallets and belts, costume jewellery, hand-printed dresses
and tweed skirt lengths. Sheepskin rugs, gloves, mitts, slippers
and hats. Soft toys, wooden toys and a large range of other
craftwork.

Key-Crafts, 20 Vine Street, Evesham, Hereford and Worcester.
Tel: Evesham (0386) 2895.
Woodturned salad and fruit bowls, platters, hour glasses, lamp
bases etc., in teak, elm, yew, ash, walnut and sycamore. Also
pottery, jewellery, candles, corn dollies and basketware.

The Society of Craftsmen, Old Kemble Galleries,
39 Church Street, Hereford, HR1 2LR, Hereford and Worcester.
Tel: Hereford (0432) 66049.
A gallery for the display and sale of work by the Society of
Craftsmen – Hereford. Pottery, jewellery, sculpture, weaving,
furniture etc.

HERTFORDSHIRE

Kimpton Art and Crafts Centre, Kimpton, Nr. Hitchin,
Hertfordshire. Tel: 0438 832236 or 832235 (recorder).
A full range of crafts and arts collectively displayed in the
gallery by about 100 individuals as an exhibition and for sale.

Digswell Arts Trust, Digswell House, Monks Rise,
Welwyn Garden City, Hertfordshire. Tel: Welwyn Garden 21506.
Digswell Arts Trust runs a community of artists and craftsmen in a large Regency house in Welwyn Garden City. Craftworkers, covering the disciplines of stained glass, pottery, weaving and printmaking, are in residence. The trust also runs two galleries. One is situated at Digswell House and shows the crafts made there, together with work from other local craftsmen. Jewellery, weaving, tapestry, pottery, stained glass etc., are on display. The second is the Gordon Maynard Gallery, 22, Parkway, Welwyn Garden City. This gallery has a mixed programme of exhibitions, each lasting for approximately three weeks. Though the programme is mixed, it includes a number of craft shows each year.

KENT

Potipher, 73 High Street, Tonbridge, Kent.
Tel: Tonbridge (073-22) 2168.
Handcraft pottery, tableware and glass.

LONDON

Amalgam Art Limited, 3 Barnes High Street,
London SW13 9LB. Tel: 01-878 1163.
Modern prints, jewellery and ceramics. Work by a wide variety of potters is stocked.

Anschel Gallery, 33e Kings Road, London SW3 4LZ.
Tel: 01-730 0444.
Original etchings, lithographs, silk screen prints, lino-cuts etc., by living British artists. Hand-made jewellery in silver and gold using precious and semi-precious stones. All jewellery designed and produced by British craftsmen.

Asset Gallery, 151 Fulham Road, Chelsea, London S.W.3.
Tel: 01-584 5185.
The Asset Gallery's primary aim is to show the work of contemporary artists from England and abroad and, although they show the work of established artists, they are also interested in supporting young unknown artists.

Thingummies Limited, 32-34 Ridgway, Wimbledon,
London SW19 4QW. Tel: 01-947 5369.
Hand-made or hand-finished presents, clothing, accessories and traditional toys. Exhibitors of the work of the British Toymakers Guild.

The Handweavers Studio and Gallery Limited,
29 Haroldstone Road, London E17 7AN. Tel: 01-521 2281.
Handwoven articles are on display and for sale in the gallery consisting of bags, cushions, rugs, wall hangings, tapestries and clothing items. Also handweaving etc., materials and equipment.

GREATER MANCHESTER

North West Arts, 52 King Street, Manchester M2 4LY.
Tel: 061-833 9471.
Publicly supported outlet for craftsmen in the North West. Contact: Visual Arts Officer–Nicky Arber.

Saddleworth Pottery, High Street, Uppermill, Nr Oldham,
Greater Manchester. Tel: Saddleworth (045-77) 5963.
Earthenware and stoneware pottery, both functional and sculptural, in a wide variety of glazes, all produced on the premises. Also a large range of hand crafted silver by Ken Brierley, and a range of pen and ink prints by local artist Jim Andrew.

MERSEYSIDE

Bluecoat Display Centre, Bluecoat Chambers, School Lane,
Liverpool L13BX. Tel: 051-709 4014.
A non-profit making organization, most of the work being on a sale or return arrangement. The centre shows mainly pottery, weaving, glass and jewellery.

NORFOLK

The Pilgrim's Craft Centre, The Pilgrim's House, Bacton,
Norwich, Norfolk. Tel: Walcott 332.
Open for a summer season of four months, during which time craft work including pottery, weaving, hand-made toys, hand-made jewellery, baskets, stone jewellery, patchwork, rushwork, pictures by local artists, small antiques and bric-a-brac are on display and for sale.

Studio '69', 40 Elm Hill, Norwich, Norfolk. NOR 7OK.
Tel: Norwich (0603) 22827.
In addition to a general range of various craft products, Studio '69' specializes in the production of facsimile monumental brasses and the supply of brass rubbing materials.

NOTTINGHAMSHIRE

Focus Galleries, 108 Derby Road, Nottingham,
Nottinghamshire. Tel: Nottingham (0602) 47913.
Jewellery, glass, leather, tiles, candles, cards, toys and wrought iron goods.

OXFORDSHIRE

The Cottage Craft Shop, Chipping Warden, Banbury,
Oxfordshire. Tel: Chipping Warden (029-586) 200.
Various crafts on sale including small gifts, horseshoe nail jewellery, flower pictures, pine woodware, pure Aran wool goods, toys, hanging baskets, macramé hangers etc.

SOMERSET

Quantock Design Limited, Chapel Cottages, West Bagborough,
Taunton, Somerset TA4 3EF. Tel: Bishops Lydeard 429.
Pottery in a wide range of styles made in the pottery on the premises. Also on sale, paintings, drawings and photographs.

Floral Workshop, Peart Hall, Spaxton, Bridgewater, Somerset.
Producers of dried flowers, grasses, seedheads etc., for winter decoration. These are made up into flower arrangements of many kinds, and pressed flower pictures of various sizes. Flowers are also sold loose, in bunches and in 'do it yourself' packs for the visitor who specializes in floral art but cannot grow or prepare his or her own material.

SURREY

Craftwork, 38, Castle Street, Guildford, Surrey.
Tel: 0483 77707.
Craftwork stock includes porcelain, stoneware and earthenware pottery and ceramic sculpture, handwoven rugs and tapestries, silverware and jewellery, blown and engraved glass, turned wooden bowls.

Tobycraft Galleries, High Street, Ripley, Surrey. GU23 6AF.
Tel: Ripley (0486-43) 3349.
Original works of art, pottery, wrought iron, light fittings and shades, glass and crystal, hand-made toys, gourmet accessories, garden furniture and ornaments, Welsh slate clocks, lamps, tapestry, cloaks, tabards, ponchos, bedspreads, stoles, ties.

The Harris Craft Shop, 21, West Street, Reigate, Surrey.
Tel: Reigate 40203.
A large selection of crafts hand-made by British craftsmen. Pottery, jewellery, Welsh tapestry, pewter, basketry, woodwork, wrought iron, collage, toys, flower tables and lamps, sculpture and painting.

SUSSEX

Forum Gallery, 16, Market Street, Brighton, Sussex, BN1 1HH.
Tel: Brighton (0273) 28578.
Gallery and craft shop specializing in pottery, sculpture, original prints, artistic jewellery and woodcarving. Hand-painted greetings cards are also available and exhibitions of artists work are arranged.

SUFFOLK

The Coach House, Grundisburgh, Woodbridge,
Suffolk. IP13 6TA. Tel: Grundisburgh (047-335) 569.
Specialities from all over the world. Hand-made pottery, exotic jewellery, exclusive dresses, leather belts, hats and bags.

The Deben Gallery, 26 Market Hill, Woodbridge,
Suffolk. IP12 4LU. Tel: Woodbridge (03943) 3216.
Paintings by local and other artists in addition to hand-made stoneware pottery on behalf of the Towy Community Centre of Llandovery.

WARWICKSHIRE

Peter Dingley, 16 Meer Street, Stratford-upon-Avon,
Warwickshire. Tel: Stratford-on-Avon (0789) 5001.
A selection of modern British crafts – pottery, woodcarving, fabric pictures, wallhangings, handblown glass and other printed cards, etchings, lithographs and monoprints made in the workshop on the premises.

Warwick Gallery, 14 Smith Street, Warwick, Warwickshire.
Tel: 0926 45880.
Comprehensive selection of modern graphics by English, American and Italian artists. Batiks from Malaysia, Ceramics and jewellery made locally, commissions undertaken. Hand-pronted cards, etchings, lithographs and monoprints made in the workshop on the premises.

WILTSHIRE

Crafts, Avebury, Marlborough, Wiltshire.
Tel: Avebury (067-23) 229.
Individually selected country craft work – pottery (stoneware and earthenware), hand-tooled leatherwork, basketwork, hand-printed silk, silver and iron jewellery, corn dollies, glassware, crochet work, wood turning, pressed flower work, toys in wood, wool and cloth, carved slate, tumble-polished stone jewellery, Dartington Hall woollens and hand-woven smocks etc.

YORKSHIRE

The Pottery Shop, 40 High Street, Keighley, West Yorkshire.
Retail shop and pottery workshop selling thrown high-fired earthenware by Derek Day, all of which are intended for every-day use.

Countrycrafts, 44, Low Petergate, York, North Yorkshire.
YO1 2HZ. Tel: York (0904) 28424.
Wood, wool, pottery, leather and flowercraft available.

The Village Craft Centre and Forge, 3, Hungate Lane,
Hunmanby, Nr Filey, North Yorkshire. YO14 0NN.
Tel: 0723 890453 (evenings).
Pottery, glassware, basketwork, leather goods, jewellery and many other items suitable for presents. Wrought iron and horse-shoe nail jewellery is hand-made in the adjoining forge.

WALES – DYFED

Canolfan Cynllun Crefft Cymru, (Craft Design Centre of Wales),
Tregaron, Ceredigion, Dyfed SY25 6JL, Wales.
Tel: Tregaron 415.
A permanent exhibition and sales showroom for a wide variety of crafts.

The Studio Craftshop, Tresaith, Nr Cardigan, Dyfed SA43 2JL,
Wales. Tel: Aberporth (0239) 810512.
Pottery, decorated tiles, enamel, ceramic and silver jewellery, wooden goods, leather goods, batik silk scarves, locally woven tweed, glassware, candles, fishermen's smocks, kaftans etc.

WALES – GWYNEDD

Select Design, Bryn Afon Studio, Trefriw, Gwynedd, Wales.
Tel: Llanrwst (0492) 640392.
Hallmarked sterling silver jewellery produced by hand on the premises, in addition to pewter jewellery. Also a wide range of other crafts for sale including pottery, leathercraft, carved love spoons, woodware, spinning wheels, lampshades, corn dollies, candles, toys, sheepskin slippers, Welsh perfume etc.

Things Welsh Limited, The Weavers Loft, Jubilee Road,
Barmouth, Gwynedd LL42 1EF Wales. Tel: 0341 280779.
Weavers of traditional Welsh tapestry, flannel and tweed by the piece. Range of rugs and furnishing fabric all in pure new wool. The shop is extensively stocked with high quality pottery, leatherware and baskets, together with a full range of folkweave clothing.

The Welsh Dresser, 3 Terrace Road, Aberdovey, Gwynedd,
Wales. Tel: Aberdovey 220.
Tapestry, flannel and tweed woven in Wales from 100% pure new wool, pottery and woodcraft.

Sanbach of Llandudno, 78a Mostyn Street, Llandudno,
Gwynedd, Wales. LL30 2SB.
Picture gallery, exclusive giftware, craft goods etc.